BALSALL HEATH

THROUGH TIME

Val Hart

AMBERLEY PUBLISHING

First published 2011

Amberley Publishing
Cirencester Road, Chalford,
Stroud, Gloucestershire GL6 8PE

www.amberley-books.com

Copyright © Val Hart 2011

The right of Val Hart to be identified as the
Author of this work has been asserted in accordance
with the Copyrights, Designs and Patents Act 1988.

ISBN 978 1 84868 528 4

British Library Cataloguing in Publication Data.
A catalogue record for this book is available from
the British Library.

Typeset in 9.5pt on 12pt Celeste.
Typesetting by Amberley Publishing.
Printed in the UK.

Contents

Acknowledgements

Many thanks to all those who have made this publication possible. The older photographs are drawn from many sources including: Balsall Heath Local History Society archives; Birmingham Archives and Heritage; the Birmingham Co-op History Society and the Heathan archive at St Paul's Community Development Trust. Particular thanks are due to Mick Turner, who collected and took many of the older photographs, as well as Jacqueline Ure, who researched and catalogued them.

I would also like to thank Peter Salway and Peter Cole who have taken some of the newer photographs. A big thank you must also go to William McCabe for his patience in locating and scanning many images. For support and encouragement I would also like to thank Bron Salway, Gabriel Hart, Anita Halliday and Chris Sutton. Finally, a really big thank you to Ian Edwards who has not only supplied lovely photographs but also copious quantities of expertise and vision.

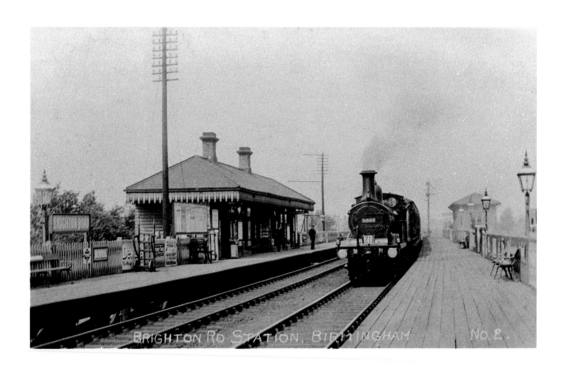

Introduction

Balsall Heath is an inner city area of Birmingham. This book looks at the period since the outbreak of the Second World War in 1939. At that point the neighbourhood was respectable working class, densely populated mainly with a pattern of terraced houses. This was ripped to pieces by the aerial bombardment of 1940 to 1942 which left a trail of destruction. Priority for rebuilding in Birmingham went to the city centre and the slow process of renewal and regeneration didn't start in Balsall Heath until the mid 1970s.

For many people living and growing up in the area in the 1950s, '60s and '70s, this was a terrible time. 'Bomb Pecks' were the children's only playgrounds. The houses were decaying, damaged and overcrowded. Many lacked indoor bathrooms or toilets.

As the neighbourhood declined it became a magnet for anyone looking for a cheap place to live and newcomers were not always welcomed by the surviving pre-war residents. Added to this was street prostitution which developed from the 1950s onwards. By the 1970s the area had a vivid reputation as Birmingham's red light district, with some roads now nearly taken over by brothels.

However, the tide was turning. Gradually the Urban Renewal programme began to have some effect. The areas around Balsall Heath Road, and Edward Road, which had been where the earliest developments had taken place in the 1830s, were now drastically demolished and rebuilt. To some extent the roads themselves changed shape. Green spaces were created as well as a major thoroughfare in Belgrave Middleway. Mercifully the tower blocks which have become the hallmark of Highgate and Ladywood, were not built in Balsall Heath. Instead there emerged a mix of new terraced housing together with large scale refurbishment of some of the existing housing stock.

Meanwhile the population was changing. Many of the pre-war residents were rehoused as whole streets were cleared and some chose to move out anyway. In their place came people from further afield, particularly from Ireland, the Caribbean, Pakistan, Bangladesh, India and Africa. The shops began to change to meet the needs of the newer residents and new places of worship were established. The Sikh Gurdwara in Mary Street was the first in Birmingham and the stately Central Mosque on Belgrave Middleway was completed in 1969, to become a focal point for Muslims throughout Birmingham.

Relationships between the diverse communities were amazingly harmonious. Community organisations developed including the BHA

(Balsall Heath Association) from 1963, St Paul's Trust from 1972, TASC (Tindal Association for School & Community) from 1975 and BRAG (Balsall Heath Residents Action Group) from 1977. Better Balsall Heath Campaigns were promoted and in 1992 Balsall Heath Forum started its work to support the residents. A strong sense of community spirit grew. The various faith groups, Housing Associations, and schools were also consistently promoting a united belief in the neighbourhood as a whole.

However, the issue of prostitution, with associated crime and drugs, continued to blight the area. Police initiatives had little effect and local residents became increasingly angry and upset. They themselves launched a controversial campaign against prostitution in 1994, called Streetwatch, patrolling the streets with some limited support from the police. Some residents felt very uncomfortable with this but in fact it was effective. Residents and local action laid the basis for the new Balsall Heath.

In the light of all this struggle it seemed particularly awful that the area suffered a new attack in 2005, this time from a tornado, which left a whole new swathe of devastation. Yet again, Balsall Heath has pulled together as a community to rebuild and develop.

Today it is still in some ways a disadvantaged area with poor health statistics and high unemployment, but it has much to boast about. There are a host of active and committed residents' groups, faith organisations and community groups. It has also become a recognised example of successful regeneration, an area rich in active citizens, where house prices are rising and new businesses being established. Our attractive and diverse community has now become a place where people are proud to live.

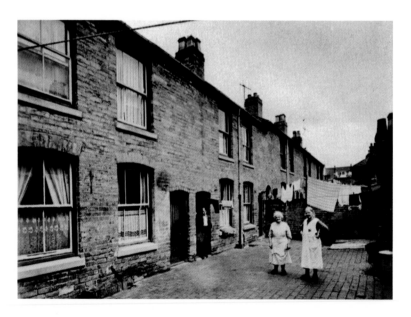

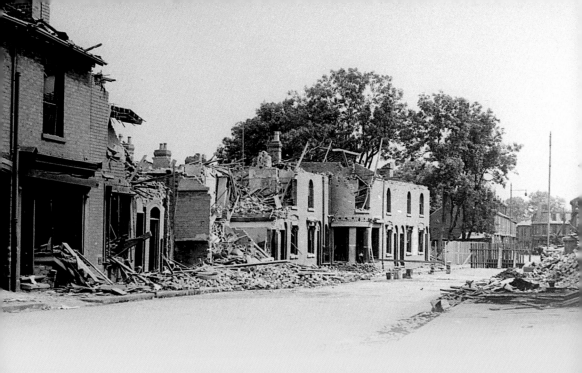

CHAPTER 1

Bomb-Damaged
Balsall Heath

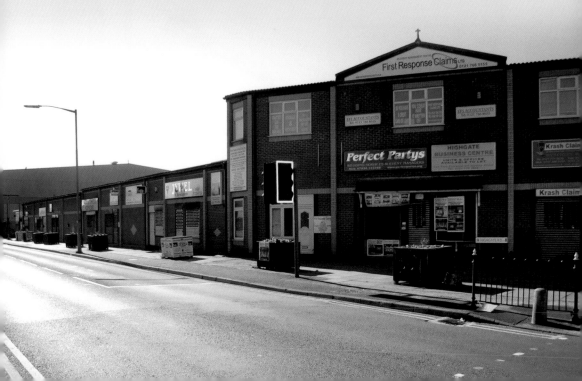

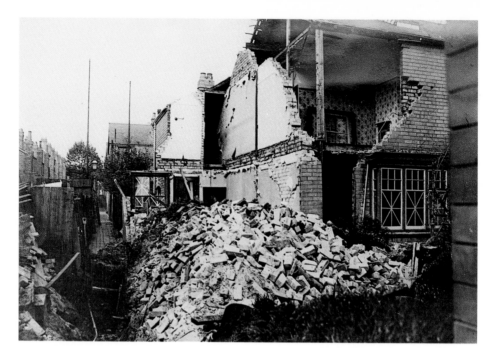

Vine Avenue, Runcorn Road, 1940

Birmingham was the most heavily bombed city outside London, and certainly Balsall Heath suffered badly. The worst of the raids started in August 1940 and Vine Avenue was hit on 18 September. The windows had been crossed with tape to prevent shattering but were no help in the case of a direct hit. Today, most of Runcorn Road has survived and has been much improved.

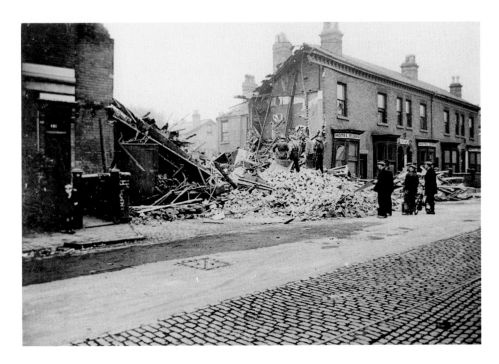

Belgrave Road

29 September 1940. Residents watch as Air Raid wardens appear to be searching the rubble. Belgrave Road was extensively damaged and has now been completely cleared of all pre-war buildings. It is an important route from the city and today features the Central Mosque, The Wand Medical Centre and the new Joseph Chamberlain College.

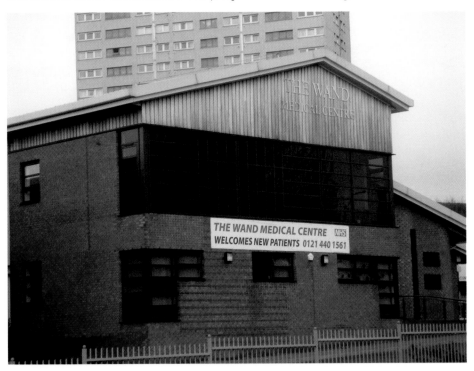

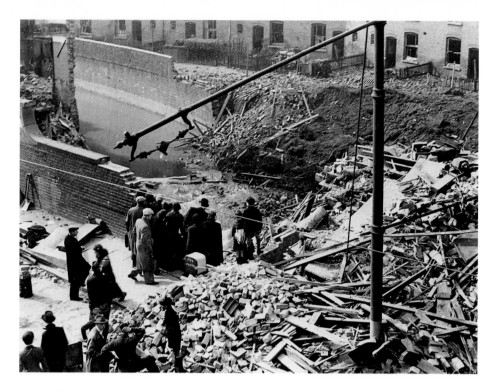

Gooch Street

The proximity of the River Rea was probably one of the reasons that Gooch Street was so heavily bombed from the autumn of 1940 onwards. The photograph above shows damage by the bridge. The road has been redeveloped and an attractive sign added to the bridge.

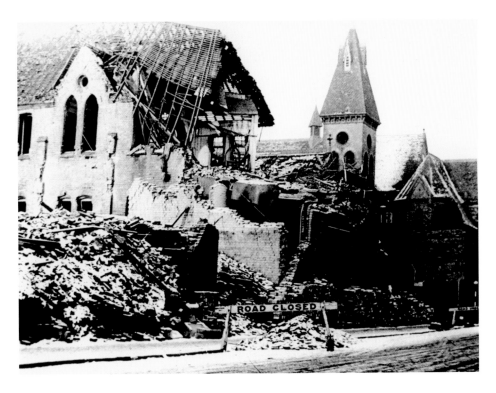

Mary Street School

1941 got off to a bad start with the bombing of Mary Street School on 3 January when the original Victorian buildings were hit. The school re-opened but has now been replaced by Heath Mount School which opened in 1970. The site of the old school has been redeveloped with housing.

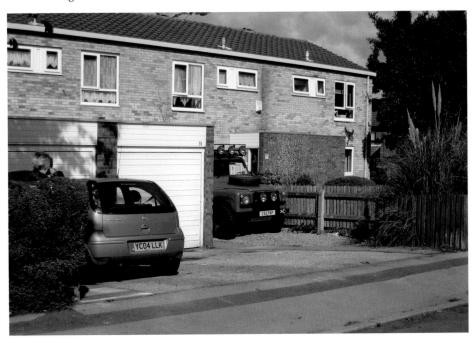

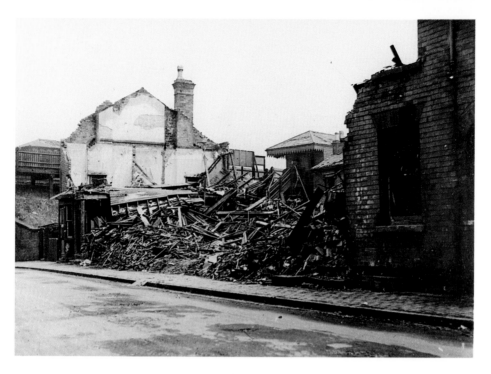

Runcorn Road

Another clear target for air raids was the railway line running through Balsall Heath. The photograph above was taken on 24 February 1941 and shows the platform and a part of the station building of Brighton Road Station. The railway line is still in use today but not for passengers.

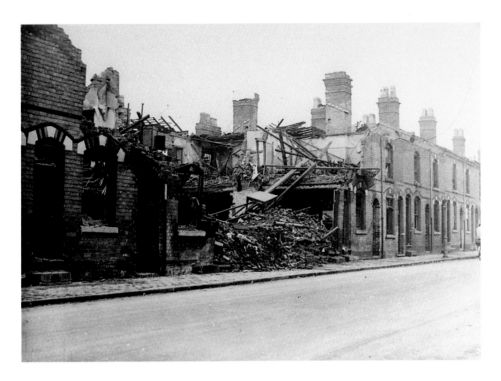

Oldfield Road

Housing was hit by this air raid on 21 February 1941. This road has been redeveloped piecemeal with some sections of new houses added to the pre-war houses, unlike the redevelopment the other side of the Moseley Road.

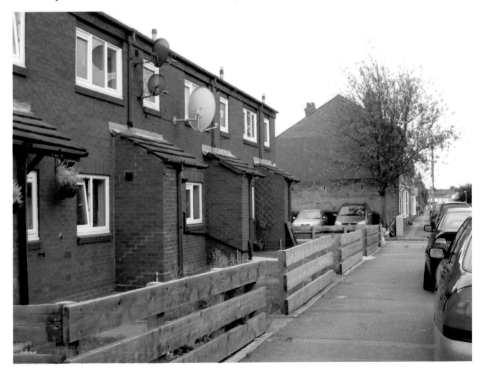

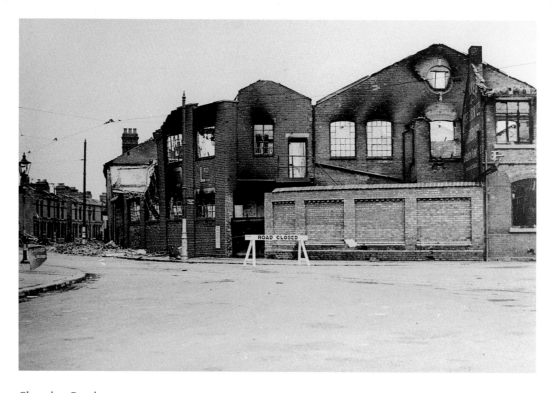

Clevedon Road
12 April 1941 saw one of the local factories destroyed, Parker T. Osborne's. Today this part of Balsall Heath has changed completely with plenty of open green spaces, trees and landscaping.

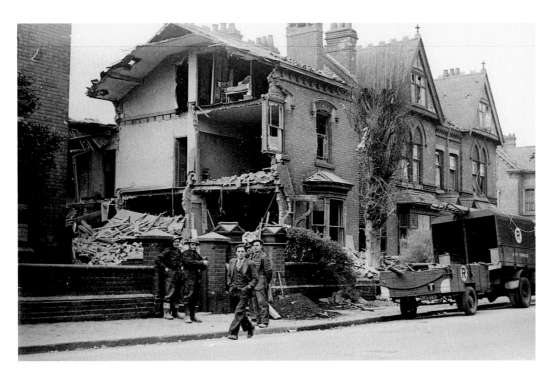

Balsall Heath Road

Once a road which boasted some elegant housing, it sustained a lot of damage in the air raids. The photograph above dates from 12 April 1941. The Rescue Services and Air Raid Wardens were well in charge of the scene, however. Today Balsall Heath Road is considerably more tranquil with a mixture of post-war houses and large green open spaces.

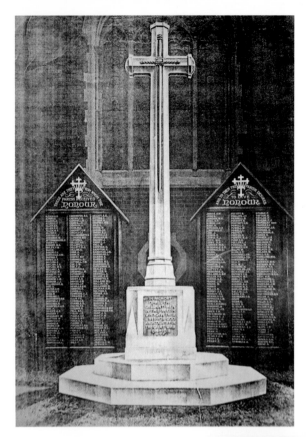

Balsall Heath War Memorial
This imposing cross originally stood near the entrance to the old St Paul's Church on the Moseley Road. When the church was demolished, the top part of the cross was saved and mounted on the wall outside the Church Centre as a memorial 'to the gallant men of this parish' who died in both world wars.

CHAPTER 2

Urban Renewal and Regeneration

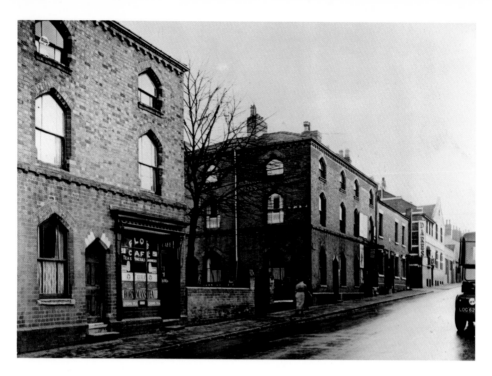

Belgrave Road

Flo's Café and Dare's Brewery which stood in Belgrave Road are now replaced by the dual carriageway of Belgrave Middleway and the gracious buildings of the Birmingham Central Mosque. This was completed in 1969 and was said at that time to be the largest mosque in Europe.

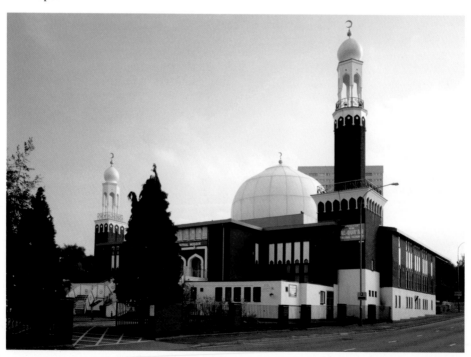

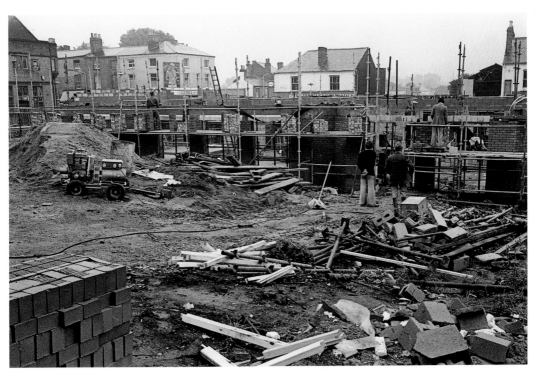

The Church Centre

A landmark in Edward Road is the Church Centre which opened in 1980, providing a home to two churches: St Paul's and The Church of Christ, both of which moved out of old premises on the Moseley Road. The Centre provides a valuable venue for community groups and events as well as running a day centre for the elderly.

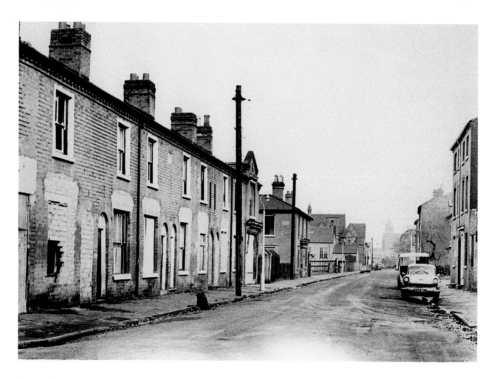

Mary Street

This part of Mary Street from Edward Road to Balsall Heath Road was completely demolished and rebuilt. The photograph above from 1970 shows the empty houses boarded up and Belgrave School (formerly Mary Street School) can just be seen on the left hand side. The whole area was rebuilt from scratch with terraced housing.

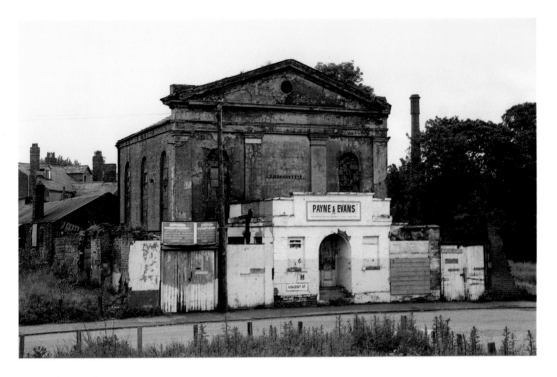

Vincent Street

The Methodist Chapel in Vincent Street was the first religious institution in Balsall Heath, built in 1839 with seating for 100. It closed in the late nineteenth century and was used for all sorts of purposes until it was finally demolished in 1987 to make space for the new road 'Haden Way'. This road is now well established with some housing and some adjacent green space. The lower half of Vincent Street has been redeveloped to provide housing.

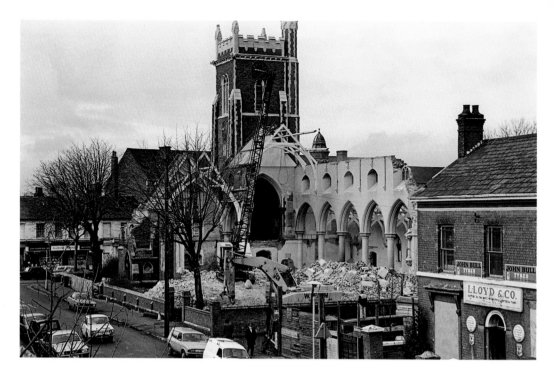

St Paul's Church

It was a brave decision to demolish St Paul's Church which had stood on the Moseley Road since 1853. In its time it was extremely fashionable, serving Balsall Heath and Moseley with a large and active congregation. However, by the 1970s it was difficult to make best use of the inflexible space inside and costly to maintain. Today the site provides small business units.

St Paul's Road / St Paul's Avenue

For many parts of Balsall Heath, Urban Renewal meant complete demolition and rebuilding. Residents often resisted this, believing that all they needed was refurbishment of their existing houses. St Paul's Avenue was a typical example of such a conflict. After a long struggle, half of the Avenue was retained and it can be seen in its current form, facing onto Pickwick Park.

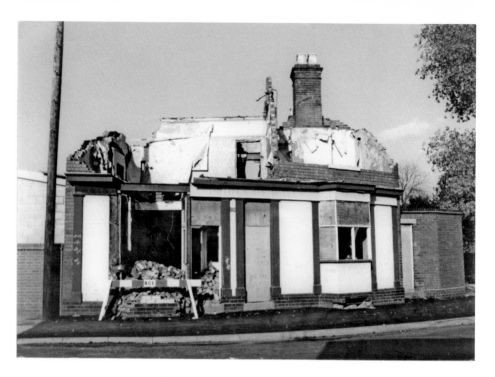

Clifton Road

The top of Clifton Road between the railway bridge and the Moseley Road was once mainly housing with the Prince of Wales public house standing just near the bridge. The photograph above shows it in process of demolition in 1985, its place today taken by small workshops. However, the major feature of this part of the area is the Clifton Shia Mosque. This gracious group of buildings also includes function halls, school classrooms and a Day Nursery.

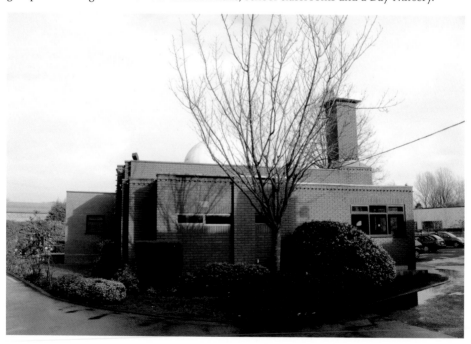

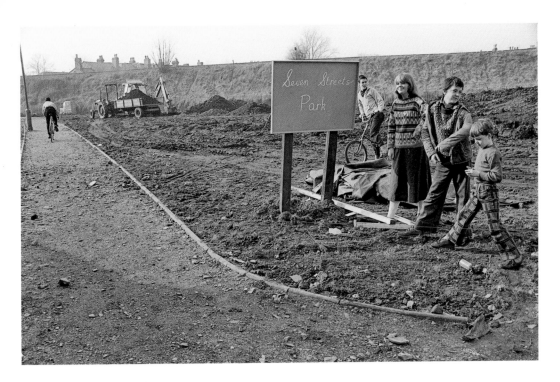

Seven Streets Park

One of the benefits of the redevelopment of the 1970s and '80s was that several new parks were created in place of some of the demolished houses. This photograph shows Seven Streets Park being laid out, a so-called 'Pocket Park'. The local children were already keen to use it before it was finished. It has had extensive use ever since.

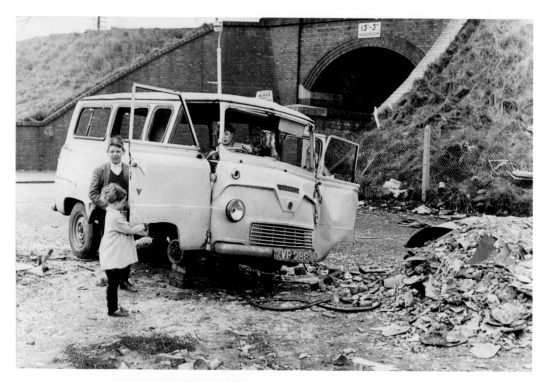

Balsall Heath City Farm

The corner of Malvern Street and Clifton Road was a derelict site in 1978 when the photograph above was taken. It provided a dangerous though exciting play space for children, especially if it also included an abandoned vehicle. Today Balsall Heath City Farm stands here, opened in 1980 to provide an educational and leisure resource for the community. The photograph below shows the author discussing sheep with the Prince of Wales when he visited in 2000.

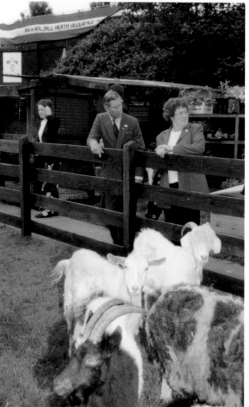

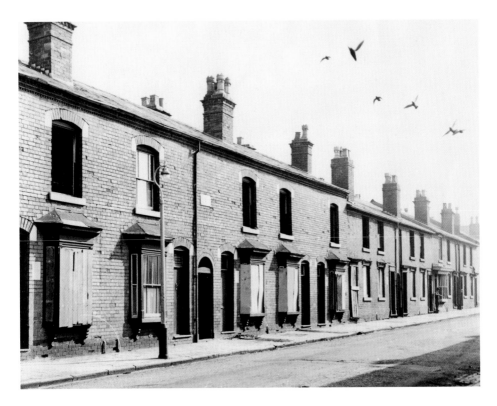

Malvern Street / St Paul's Trust

In 1966 the street of terraces was nearly ready for demolition although a few were still occupied. Today the street itself has gone, to create a green oasis comprising the Farm, The Venture (play and community centre), and Balsall Heath Sure Start Children's Centre including St Paul's Nursery.

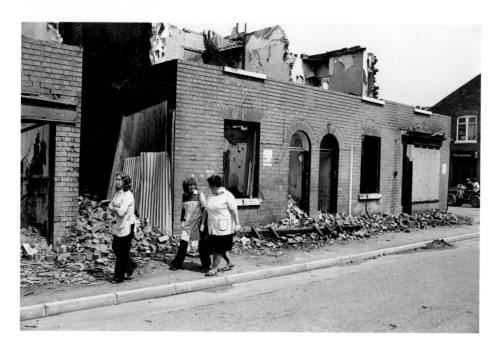

White Street / Clifton Road

Unsafe demolition practice was a frequent complaint of the residents against the various contractors and this is a good example. The houses on the corner of White Street being demolished have been left in a poor state with rubble strewn across the pavement. This was in 1980 at a time when the new Clifton Infants' School had already opened at the other end of the street so it was on a route to school. The photograph below shows the site today.

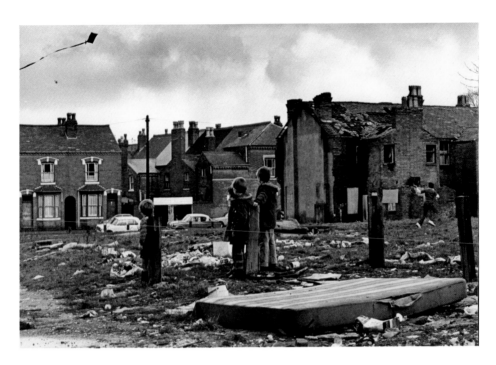

Brunswick Road

In 1975 this was the children's only playground, surrounded by derelict houses and rubbish. This part of Brunswick Road between Ladypool Road and Stoney Lane is where another park has been created with a shiny modern playground, backing on to Nelson Mandela School which opened as a new build in 1987.

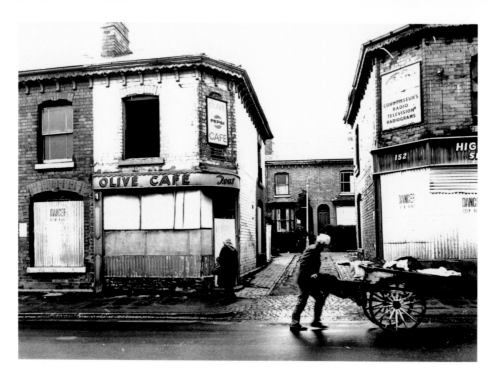

Olive Café / Highgate Road

The Olive Café in 1977 was no longer serving teas or Pepsi Cola. It was awaiting demolition. However, not all the surrounding houses were vacated. In the 'back houses' someone is standing by the gate and there are still curtains up. This was the experience of many residents as some were left behind for too long while others moved out. Today, this stretch of Highgate Road is mostly green corridor though the Karachi Grill stands approximately where the café was.

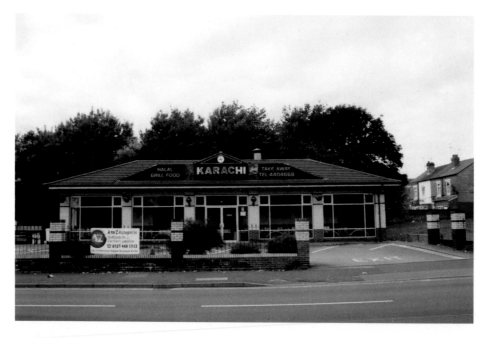

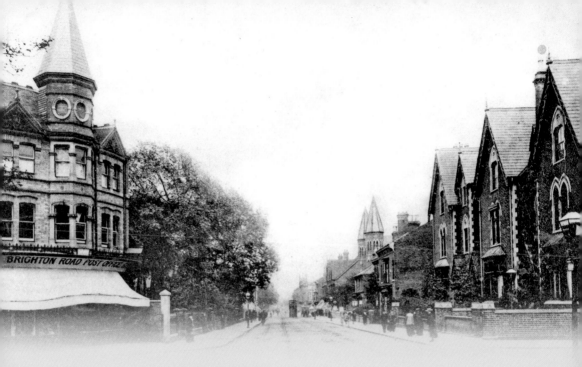

CHAPTER 3

Moseley Road

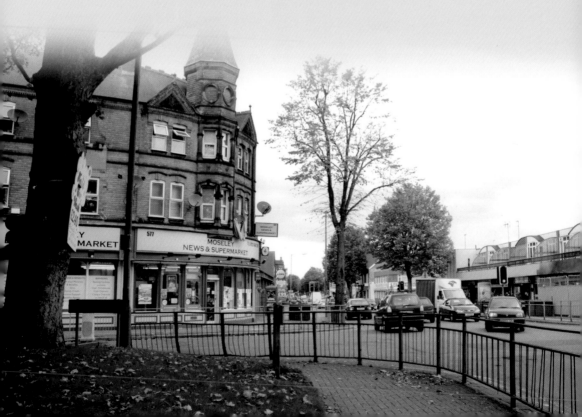

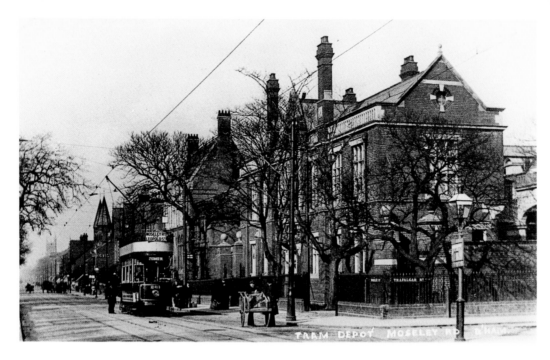

Moseley Road Tram Depot / Creation Climbing Centre

Built in 1906 to fit with 'the select residential area' around it, these imposing buildings once housed firstly electric trams and subsequently motor buses. Today the huge workshops at the back have found an amazing new use as the Creation Climbing Centre providing both exciting and safe facilities for indoor climbing and BMX bikes.

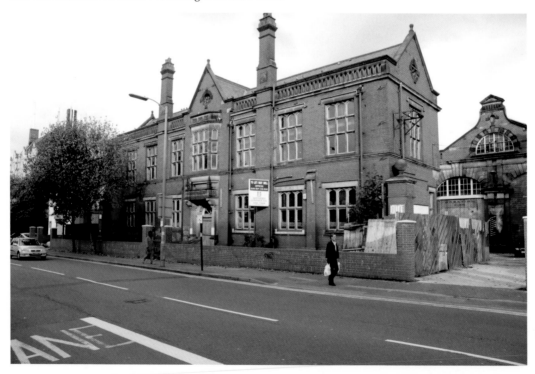

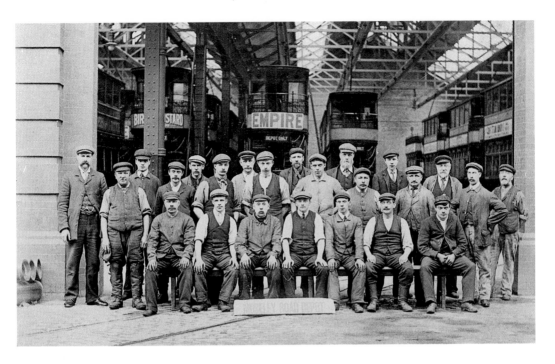

Inside the Tram Depot

The group of workers above are posed at the front of the workshops. The size of the place is indicated by the trams behind them. Caps were obviously essential wear. The man standing at the left side of the group is sporting a watch chain and was probably the foreman in charge. The space today is being well used by people of all ages.

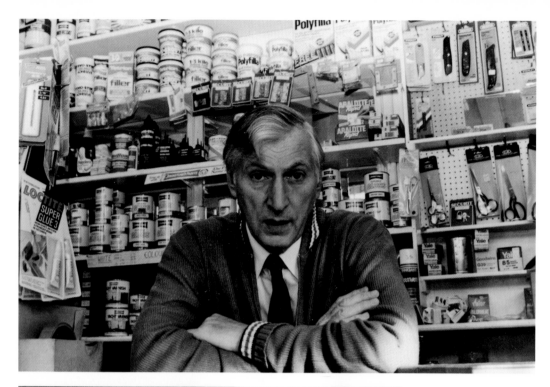

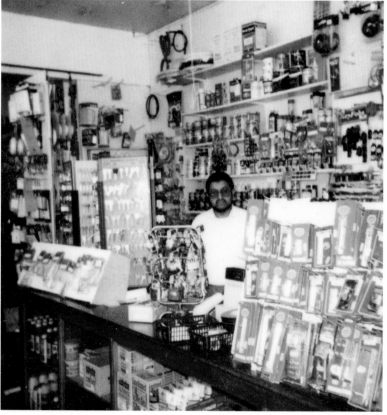

Shopkeepers
This hardware shop is probably the longest surviving shop on the Moseley Road. Originally White's China & Glass shop, it stands on the corner of Homer Street. The earlier picture is of Mr Hanley who ran the shop as Sandbrooks for many years. Now it is in the hands of Mr Saifee, still continuing to sell hardware to local people.

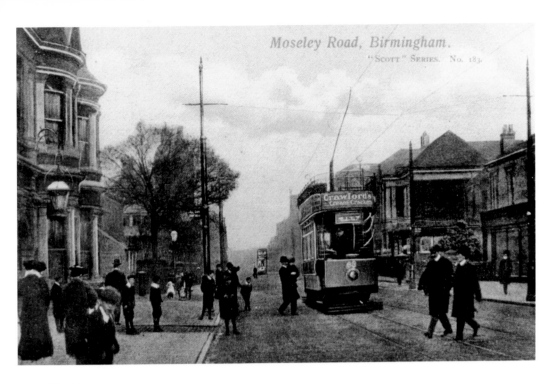

Moseley Road, Birmingham.
"Scott" Series. No. 183.

The New Inn

At the heart of the Moseley Road, the Edwardian postcard view shows the New Inn on the left of the image. The pub itself is Victorian but is now in process of a change of purpose. It is to be the site of a new pharmacy, well placed near to Balsall Heath Health Centre. However, its splendid Victorian tiles and fittings are also to have a new life.... as part of an Irish theme pub in Las Vegas!

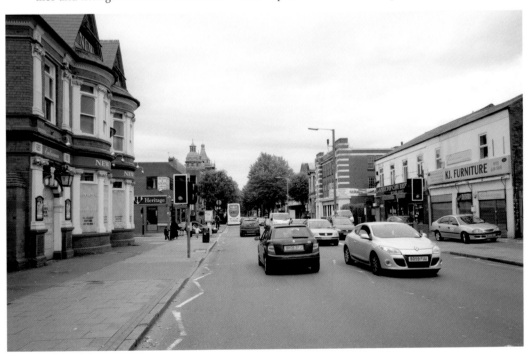

J. H. Butchers' Factory
This was one of the major companies with premises on the Moseley Road from 1909 for nearly a hundred years. They produced transfers of all kinds and called on the skills of many ex-pupils of the Moseley Road School of Art next door. Butchers has now moved to Redditch but the place is also currently starting a new life as the Make It Zone, Enterprise Craft Workshops for young people.

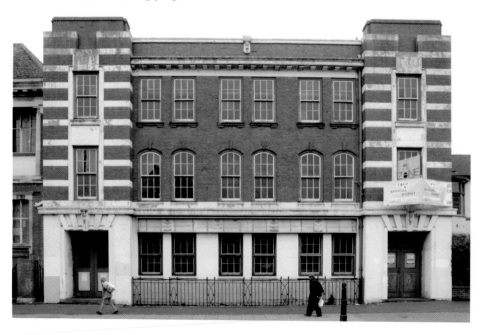

The Church of Christ /
Islamic Student House Masjid
Originally opened in 1912 with seating
for 400, the Church of Christ was
built to replace the chapel in Charles
Henry Street which dated from 1857.
However, in 1980 they moved to share
the splendid Church Centre building
in Edward Road with the congregation
from St Paul's Church. Today, it is still a
faith based building, refurbished and in
use as a Muslim Students' House Masjid.

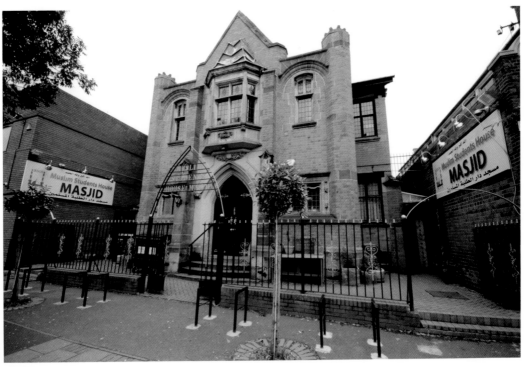

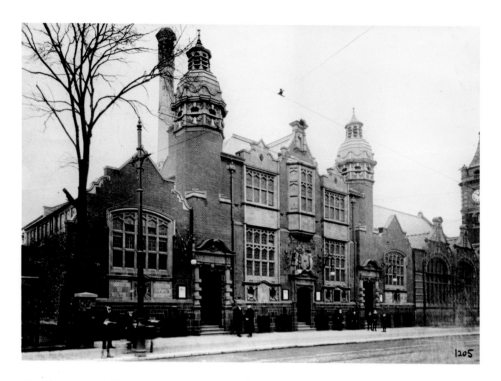

Moseley Road Baths

This grand building was opened in 1907 by Birmingham City Council together with the Library, as a reward for Balsall Heath agreeing to annexation. The photograph above is from 1910 when it contained two pools, separate washing baths for men and women and a laundry. Today its future is uncertain, and the First Class pool is closed needing repair. The Second Class pool is heavily used, the photograph below showing school pupils *en route* to a swimming lesson.

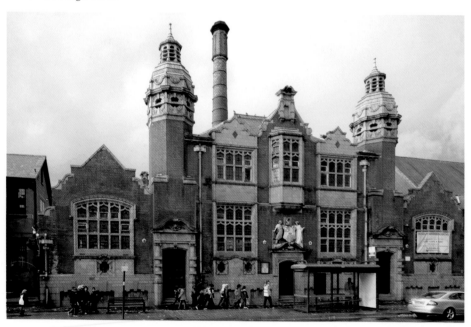

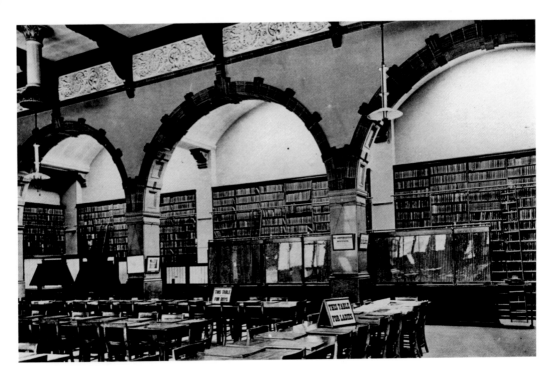

Balsall Heath Library

Originally opened in 1896, the photograph from 1910 shows that no conversation was permitted and there were separate tables for ladies and gentlemen. A hundred years later the library interior has been reshaped to provide a large and welcoming space for children and families, funded by Balsall Heath Sure Start.

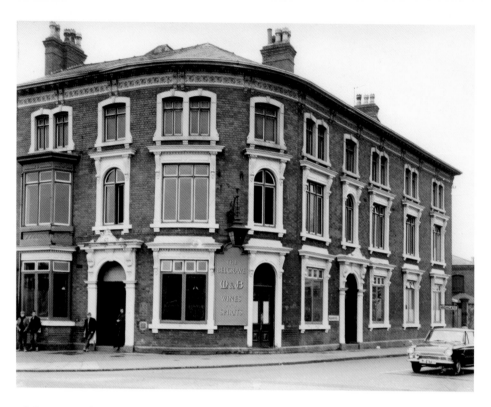

Highgate Road Junction / Chamberlain College

The Belgrave Hotel above was built in 1878 by William Charley, a local entrepreneur. The photograph was taken in 1967 when much of Balsall Heath was being redeveloped. Today this commanding site is occupied by Joseph Chamberlain College which moved here in 2008.

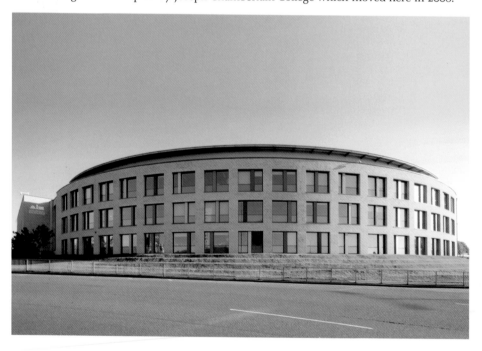

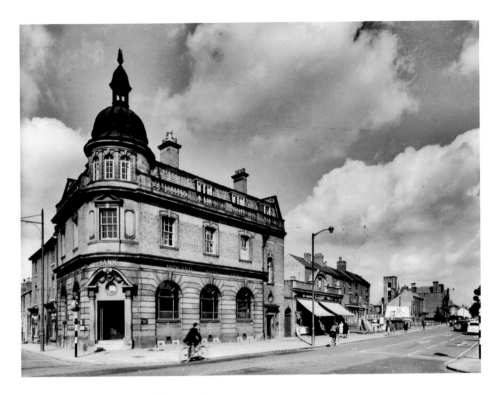

Highgate Road Junction / Fire Station

On the opposite side of the road stood this bank in 1910, a fine building creating an impressive gateway to Balsall Heath. This was a tram route but also in the photograph are bicycles, horses and carts. Today, the site has been occupied by Balsall Heath Fire Station since 1972, making best use of a key position for quick routes in every direction.

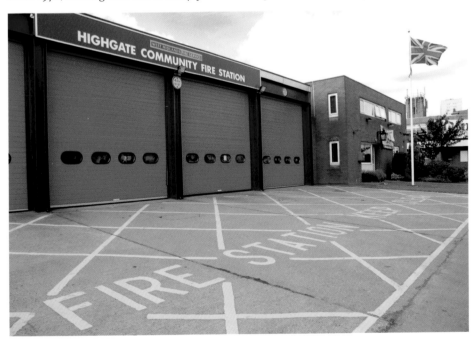

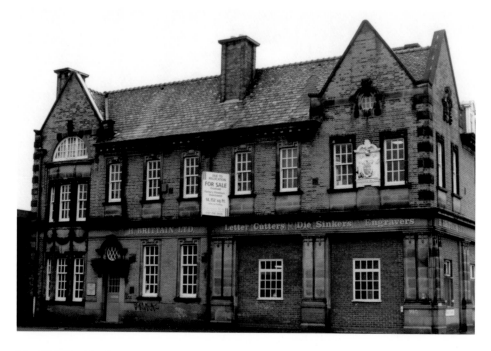

The Old Fire Station

This building was the area's pride and joy when it opened in 1912 and still displays the City Coat of Arms. After the move in 1972 it was used by Brittain's Die Sinkers & Engravers, but has now found a new use as BISPA, Birmingham Independent School of Performing Arts.

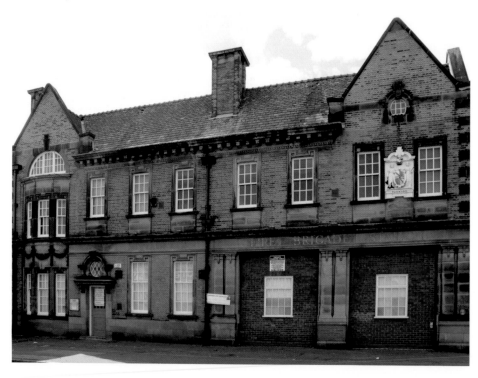

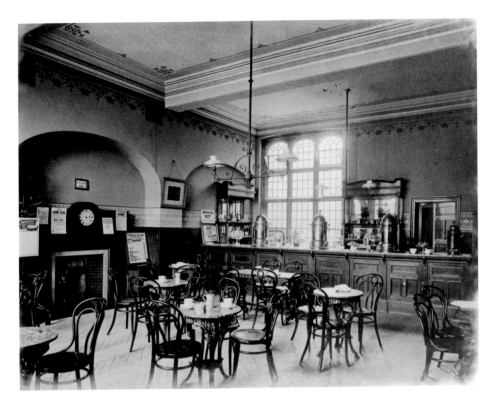

Refreshments at the Friends' Institute

In 1899 when the Friends' Institute opened, the elegant coffee room was beautifully furnished and smoking was not allowed. Still serving refreshments today, the Matchbox Café is run by a team of adults with learning disabilities.

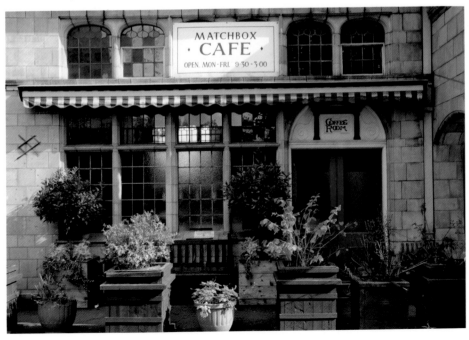

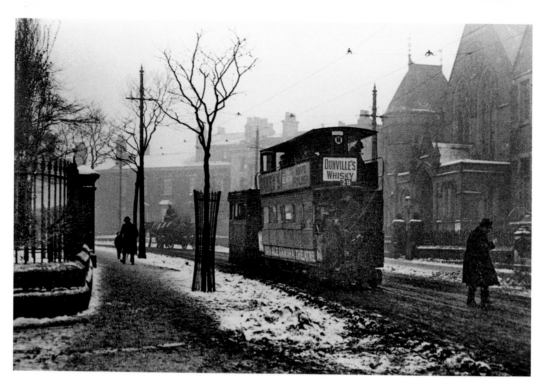

Transport by Highgate Park

The steam tram is passing Highgate Park on a snowy day in 1906. The route is now served by the number 50 bus which runs every five minutes to and from Birmingham.

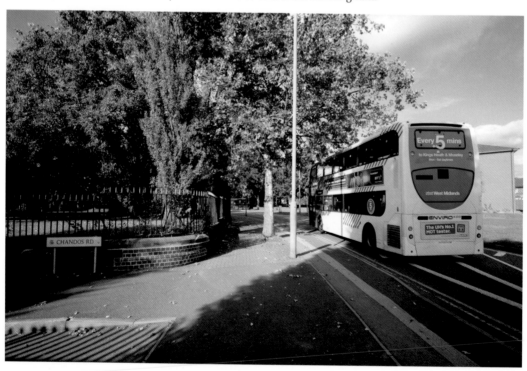

CHAPTER 4

Edward Road

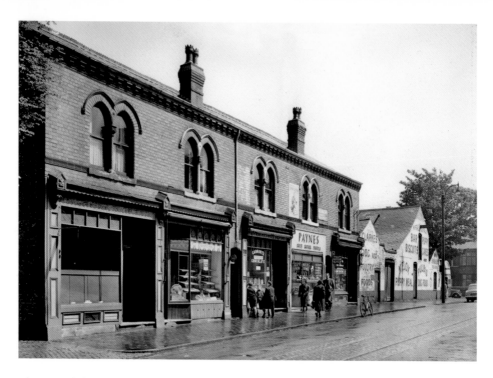

The Top of the Road

The photograph above is dated 12 May 1952, showing Acocks Green & Olton Laundry, Kath's Sweet Shop, Paynes Shoe Repair Service, Hair Cutting & Shaving Rooms and Clarkes Dog and Poultry Food Factory. A sign of the times is the notice in Paynes' window, 'Nylons repaired'. Today this junction is occupied by Heritage Car Showrooms with handsome frontage to the Moseley Road and a Valeting Centre at the back.

At the Side of the Baths

The photograph above shows the long roof of the Health Centre, opened in 1982 but at this time the land at the side of the baths was cleared but not yet developed. The modern photograph also shows that Midland Grove has survived. This runs at the back of the baths and in the past was used for coal deliveries.

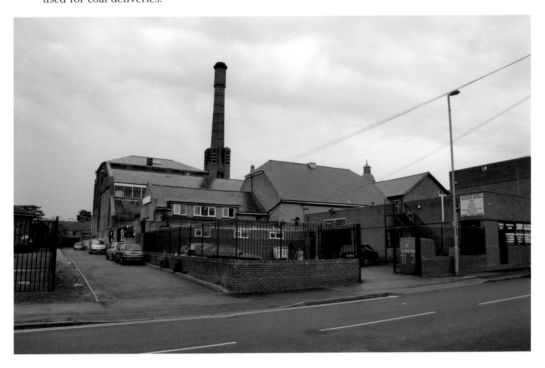

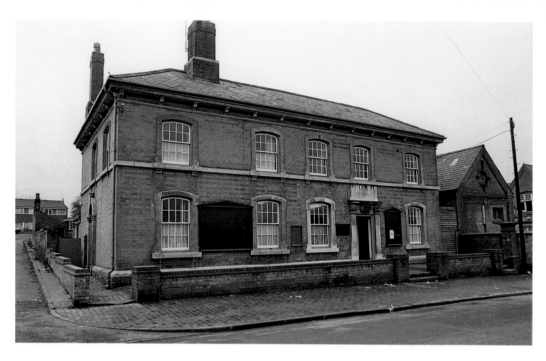

The Police Station

An important focal point for Balsall Heath both past and present. The main building is unchanged although the yard with stables which stood to the right, has gone. Modern embellishments include the hanging baskets and planters together with smaller notice boards although there are more notices!

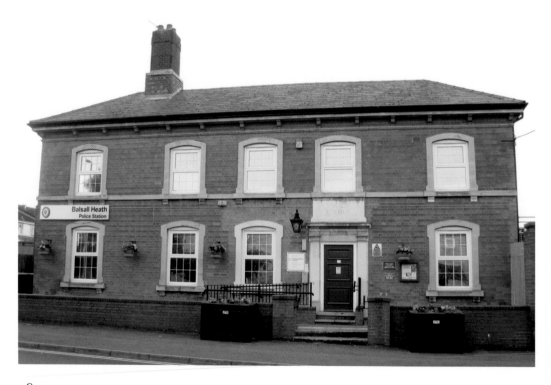

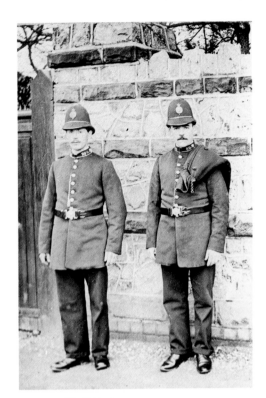

Policemen

The uniforms have changed although the helmets look very much the same. The photograph below features PC David Livingstone on the right and Police Community Support Officer Samuel Norgate, on the left. The Police Station is now partly staffed by volunteers from the community.

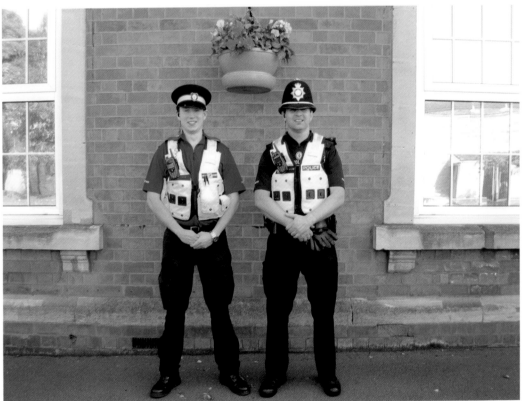

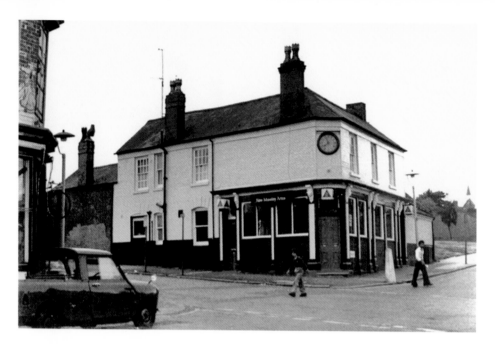

The Clock Public House

On the corner of Tindal Street and originally called the New Moseley Arms, the name seems to be the biggest change. At the left of the earlier photograph there is a curiosity. A bicycle appears to be hanging half way up the lamppost. It IS a bicycle. The shop was D&W Exchanges ('We Buy Anything') and it hung up bicycles for sale outside, until it was demolished to make way for new housing in the 1970s.

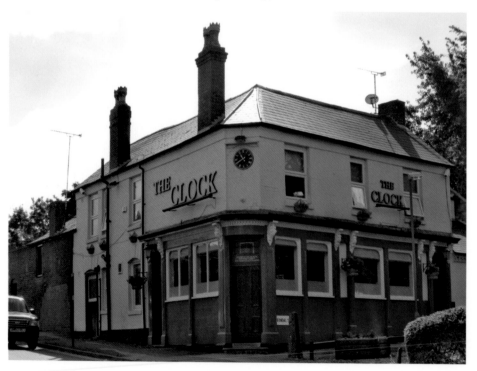

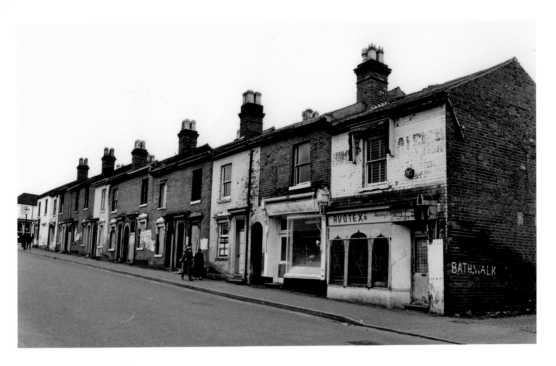

Near Bath Walk
The old terrace houses have given way to modern workshops including the Birmingham Yemeni Forum and CATS (Children's Action Team Support) which is an organisation working with children with disabilities.

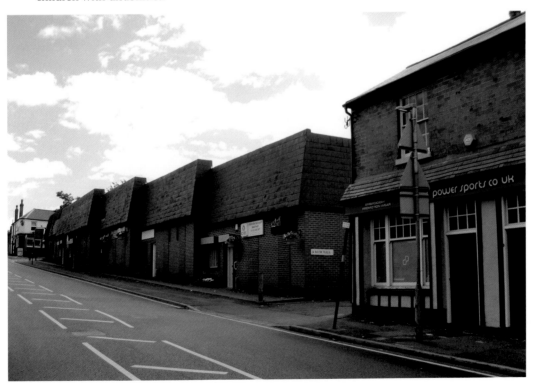

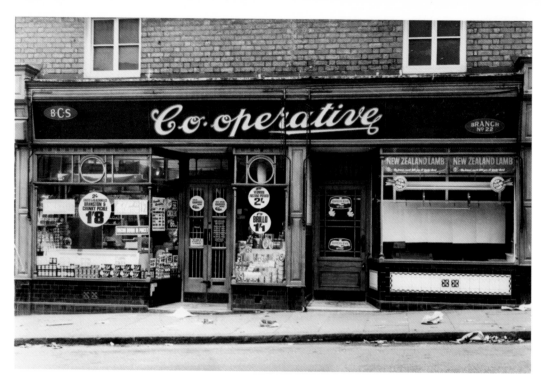

The Co-op
Edward Road was quite a busy shopping street and in pride of place was the Co-op, Branch 22 seen here in the 1950s. These days the road is more residential with leafy gardens.

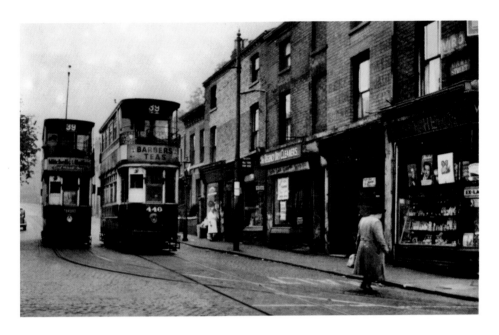

The Corner of Mary Street and Edward Road

A dramatic contrast. The photograph above shows the trams which ran up to the top of Mary Street. Some of the three-storey buildings with shops on the ground floor are still there. Regency Cleaners has given way to Gaza General Store and the newest addition on the corner is the Al Barakah Lebanese Bakery. Beyond these on the right is now sheltered housing.

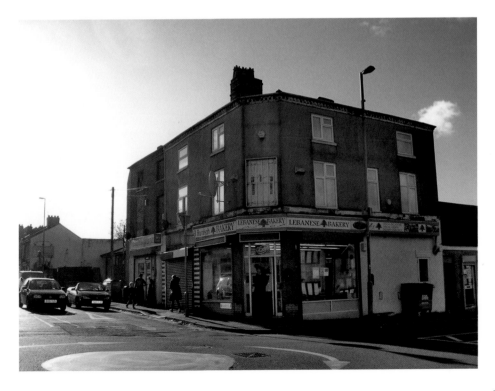

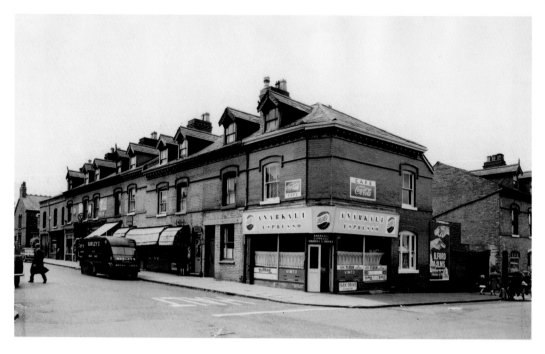

The Corner of Hallam Street and Edward Road

Another scene of contrast. The photograph above dates from 1961 with the Anarkali Café on the corner. The Hawley's bread van is delivering to Belfort's grocery shop, which gave Green Shield stamps. The same junction today shows new housing development although at the left of both photographs the terrace called Cannon Hill Grove, running sideways to the road, is still there.

Jakeman Road Junction

In 1955 the Cannon Hill Hotel dominates this part of the road. It is now no longer a pub but an outpost of South Birmingham College and the base for Saheli Women's Association. Opposite in 1955 is a very modern shop, Vision Developments Company, selling televisions, however, the milk float just round the corner is still being drawn by a horse. The scene today retains some similarities but has noticeably assertive road markings.

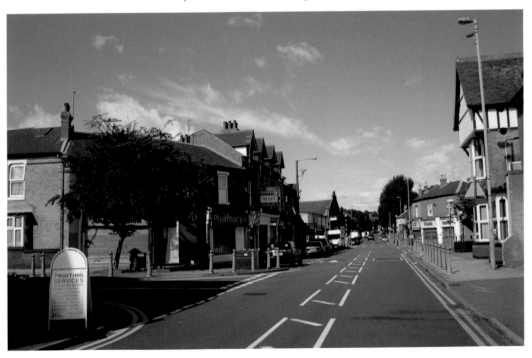

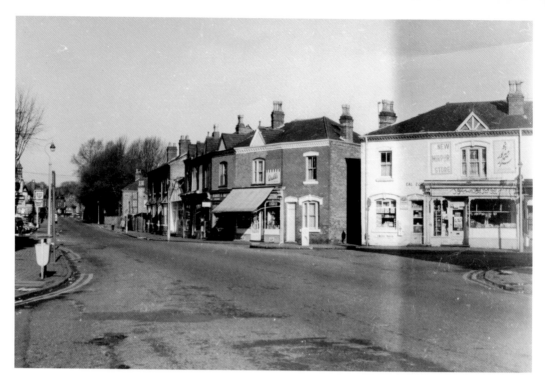

The Corner of Court Road

The sweep of the road is recognisable, with its row of shops. It's interesting to see the New Mirpur Store in the earlier photograph had opened to serve the needs of the Asian community.

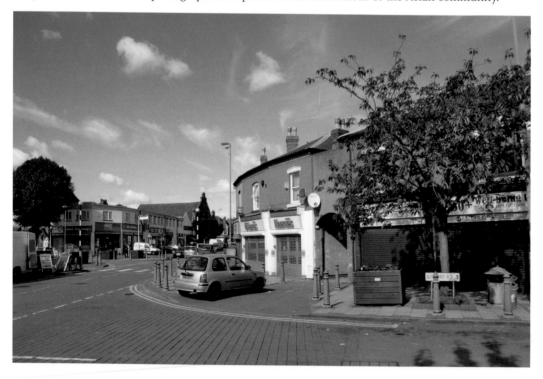

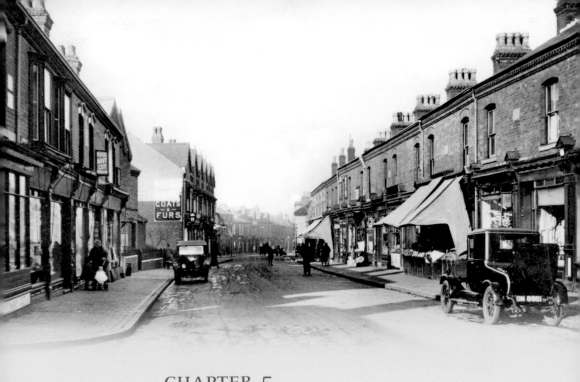

CHAPTER 5

Ladypool Road

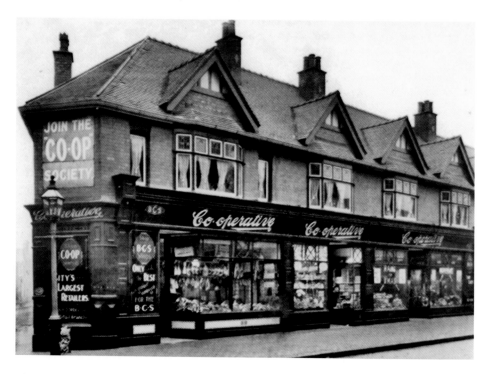

The Co-op / Uncles Home Store

This has always been the site of a large and impressive shop in the Ladypool Road on the corner of Studley Street. Once Branch 41 of the Birmingham Co-operative Society, pictured above in the 1950s, the site is now dominated by Uncles Home Store who have been trading in the road since the 1970s. The upper storey is recognisably the same.

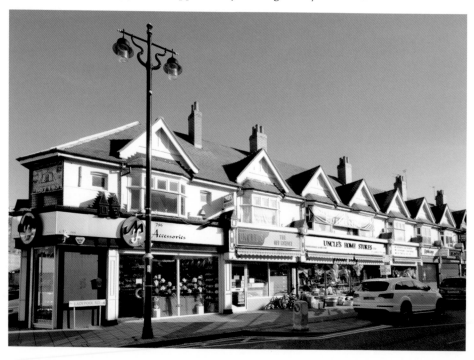

Olympia Cinema / Raja Brothers

The building was originally the Olympia Cinema, opened in 1913, but refurbished as The New Olympia in 1930 to provide for 'Talkies', still visible in the photograph above in the 1990s. It is now a shop and the Raja Brothers have taken a more radical approach to marketing with their dramatic sign on the front.

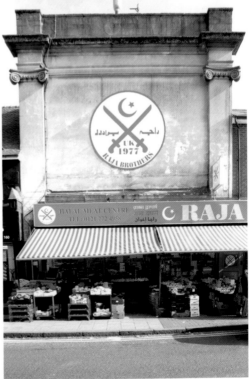

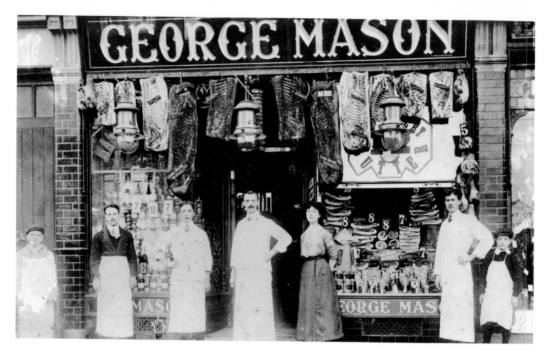

Masons / Meena Bazaar

In 1901 when the photograph above was taken, there were branches of Masons all over Birmingham. The shop sold groceries but also bacon which they sliced themselves. The meat is hanging on hooks at the front of the shop, alongside oil lamps. The shop assistants included two young boys. In amazing contrast is Meena Bazaar which is one of the exciting high quality Asian clothing shops which are now becoming a strong feature of the road.

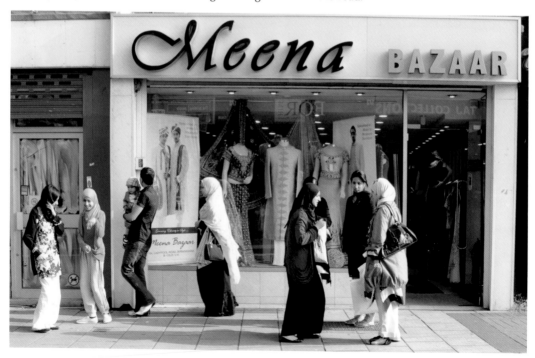

The Congregational Church

Originally opened as a Mission Church in 1894, an unusual feature of this church has always been the shop built into the front of it. At one time this was a butcher's, with beautiful tiling. It has now become home to the Second Chance charity shop, run in aid of the church itself.

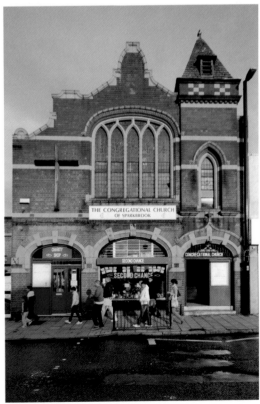

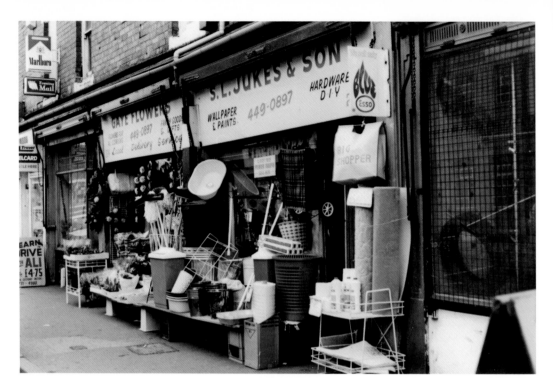

Jukes / Dhadkan

The photograph above shows Jukes and Gaye Flowers shops in the 1990s. An amazing array of goods were on sale including 'Esso Blue' for paraffin heaters. The pavement was used for displaying goods, a practice still popular in the road today. Dhadkan, 'The Heart of Fashion', has now taken their place with a very smart shop which draws customers from all over the West Midlands.

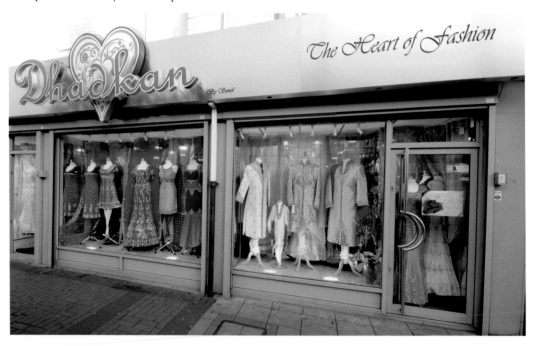

St Paul's School / Car Park

This school was one of the earliest in Balsall Heath, opened in 1858 by St Paul's Church. It had a single room divided by a curtain for separate boys' and girls' classes. The master and mistress of the school lived on site as can be seen by the washing hanging in the school yard. The site has now become a car park serving visitors to the increasingly prosperous and attractive shops along the Ladypool Road.

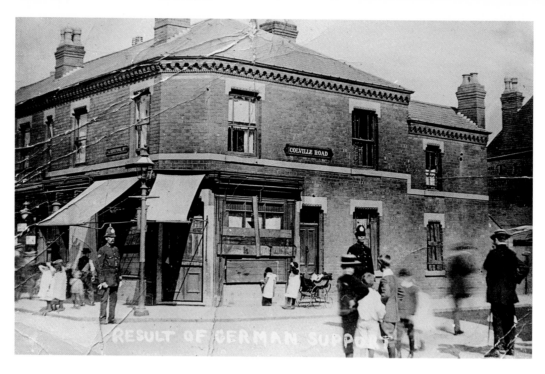

Colville Road Corner / Lahore Village

Mr Stile's pork butcher's shop in 1914. Mr Stiles was unwise enough to make pro-German remarks in the pub. As a result his shop was attacked and he was forced to give up his business. Today the Lahore Village has made impressive use of the site, one of the many restaurants in the road which have earned it the name of 'The Balti Belt'.

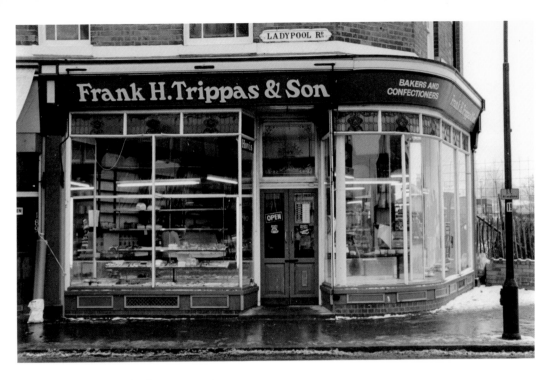

Trippas Bakers / Lahore Sweet Centre

This was always one of the finest shops in the road. At one time it was Trippas, Bakers and Confectioners, with their own bakery premises a few doors away. The rounded glass windows have survived and inside there are shelves with mirrored backs. It is now the Lahore Sweet Centre selling goods to reflect the taste of the local populace.

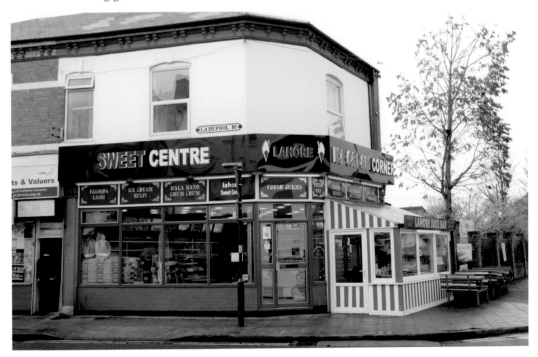

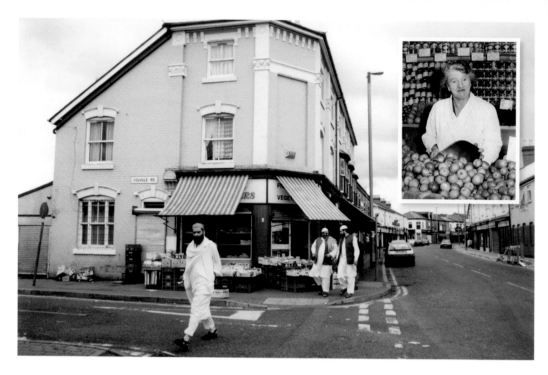

Colville Road Corner / Lahore Pizza

For many years this was a shop run by the Jones family and the inset photograph shows Mrs Jones selling apples. It stayed as a greengrocer's for some time but has now been replaced by Lahore Pizza.

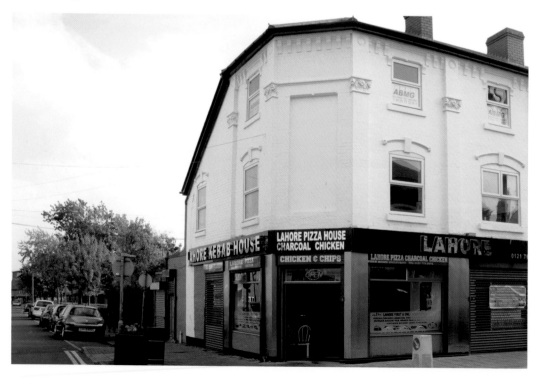

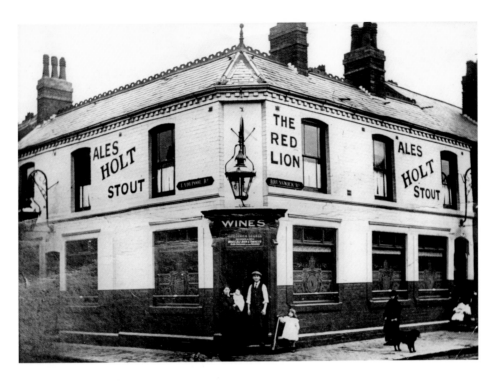

The Red Lion / Desi Express

One of the road's traditional public houses with Frederick George, the landlord, and his family. It's interesting to note that the little girl has a very modern looking scooter! It is now the Desi Express, a fine example of creative re-use of older buildings.

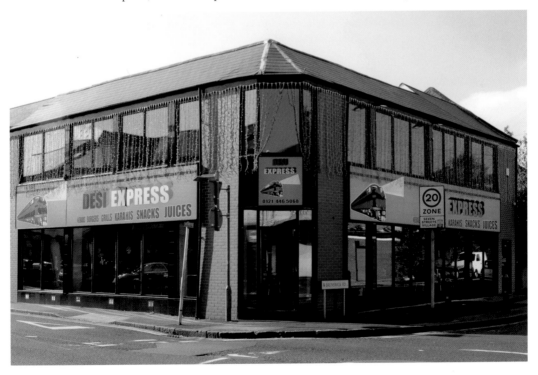

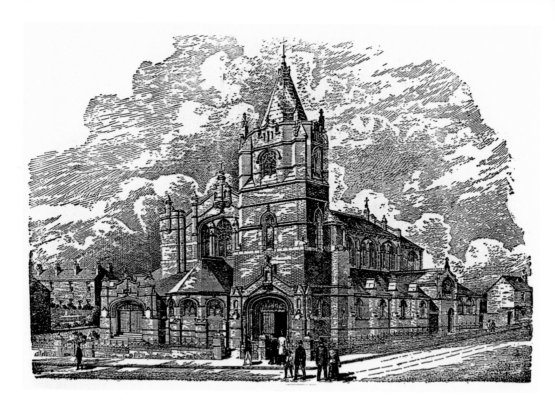

St Barnabas Church

This church started out as a tin hut mission of St Paul's but gave way to a truly splendid new church building in 1904. It suffered heavy damage from bombing in the Second World War. However, the surviving part of the church has been imaginatively adapted and the hall at the side is now in use as a nursery run by Balsall Heath Sure Start Children's Centre.

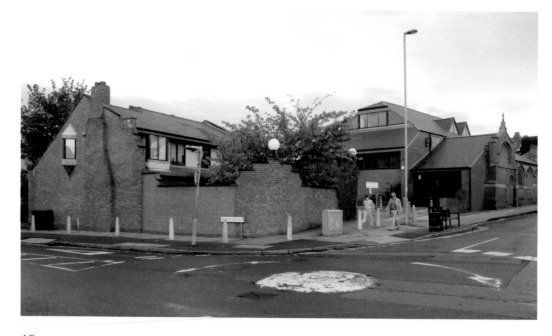

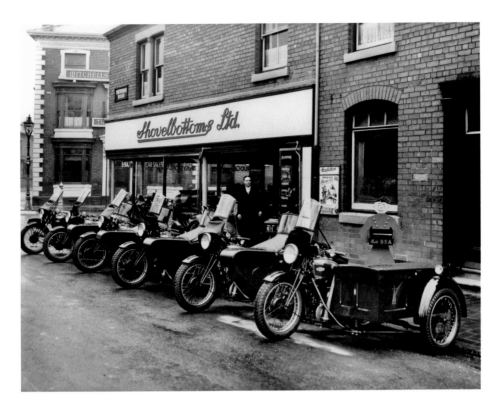

Taunton Road Corner
Shovelbottom's had a fine display of BSA motorcycles with sidecars outside their shop in the mid 1940s. Today the corner site is taken by a hairdresser's and the 'Mobile Fone Hospital'.

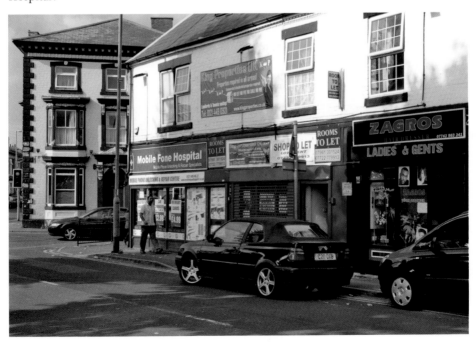

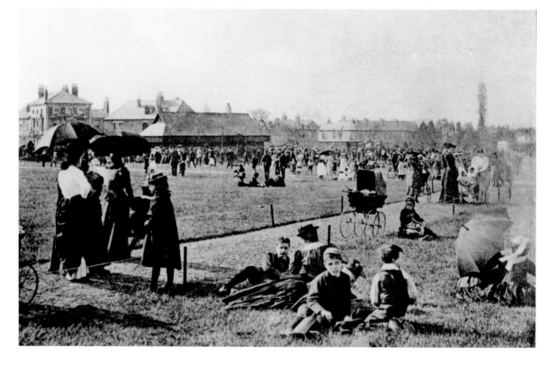

Balsall Heath Park

The new park at Balsall Heath is shown in the postcard above in 1894. The land for this was given to the city by Mr Smith-Ryland, heir to Miss Ryland who had donated the land for Cannon Hill Park. The green space was desperately needed in Balsall Heath which was densely populated and clearly the park was much appreciated by local children and families. Today the park is still heavily used, especially since it now has a bright new playground.

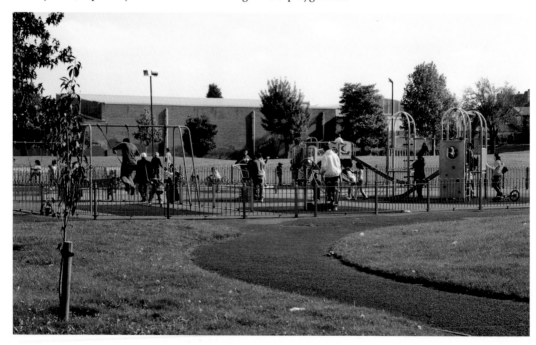

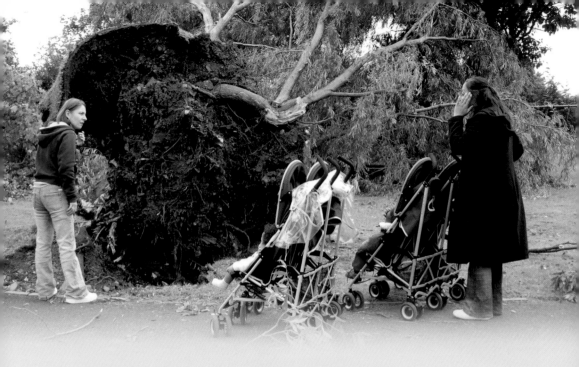

CHAPTER 6

Tornado

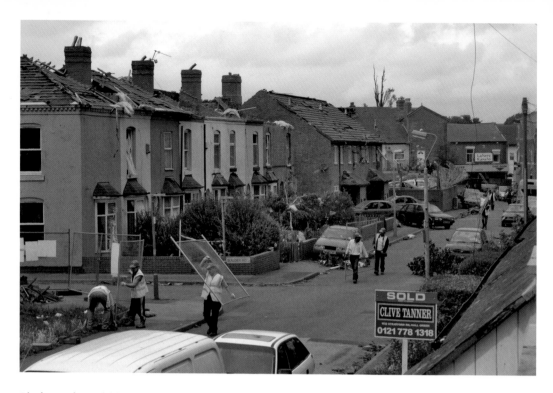

Birchwood Road (1)

was directly in the path of the tornado that struck at about 2.30 p.m. on 28 July 2005. It lasted a mere four minutes, with wind speeds between 93 and 130 mph, and passed through Kings Heath, Moseley, Balsall Heath and Sparkbrook. It wreaked unbelievable damage, ripping off roofs and flinging around sheds, garden furniture, dustbins and cars.

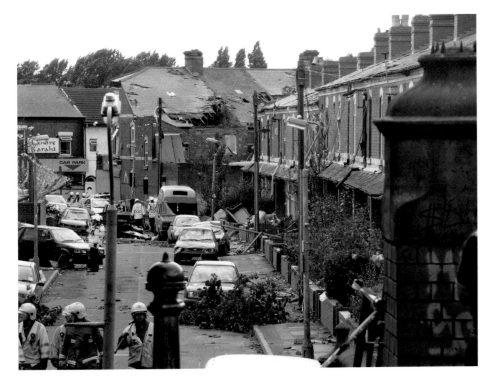

Birchwood Road (II)

The extraordinary devastation happened so quickly that it felt unreal. Altogether 169 people were evacuated to temporary accommodation and 900 council staff were involved in a massive clean up operation. There was also a tremendous amount of community goodwill with neighbours pulling together in the face of this disaster to help those in need.

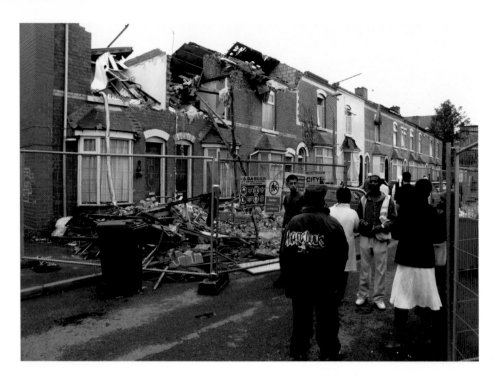

Alder Road

Residents gather in shock to look at damaged houses. There were added difficulties as some residents were not insured. A Tornado Hardship Fund was set up which eventually received a donation of £100,000 from the City Council in May 2006. Recovery was slow. As late as September 2006, some people had still not been able to return home. Thankfully the road today is fully restored.

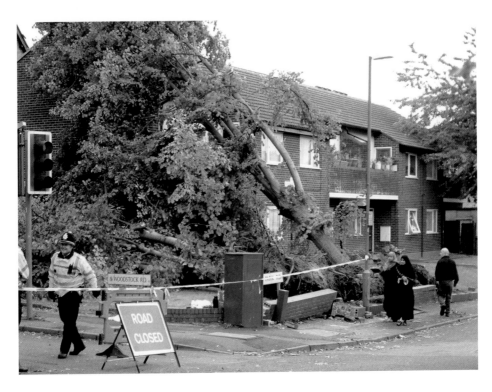

Woodstock Road

More than 1,000 trees were uprooted by the tornado and damaged anything that lay in their path as they fell. On the corner of Woodstock Road the tree fell across houses which have since been repaired.

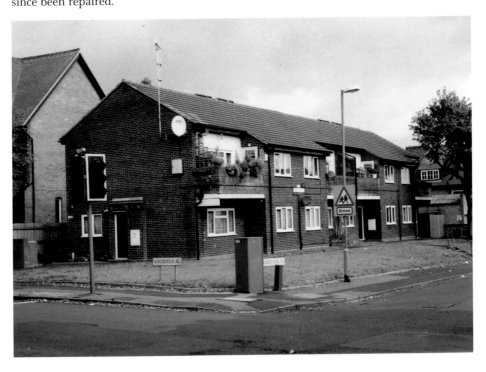

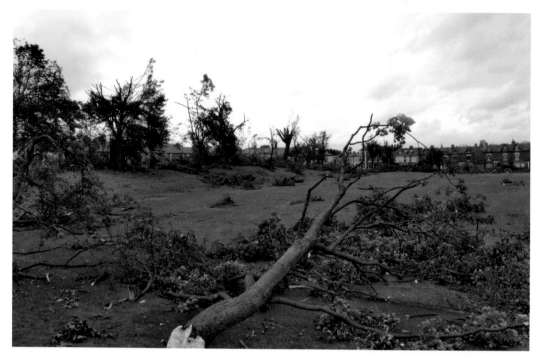

Balsall Heath Park

Balsall Heath Park lost all its mature trees and those that were left looked as though they had been attacked by a giant hedgecutter. Local residents have been active in campaigning for the restoration and development of the park, with some success. Many new trees have been planted although more ambitious plans are still on hold.

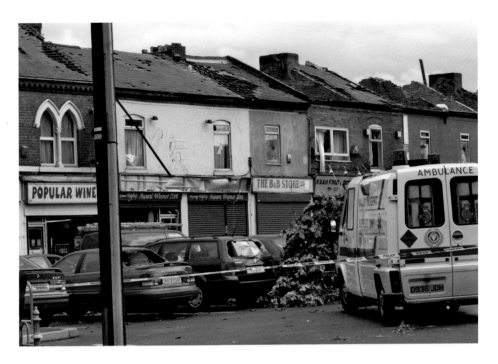

Ladypool Road

An ambulance is waiting on the busy shopping street. Amazingly there were no fatalities and relatively few severe casualties. The shops and businesses were severely affected, however. In Ladypool Road itself, 114 out of 158 businesses suffered some damage. The road is now transformed thanks to major efforts by shopkeepers and grants from the City Council. In fact, the road continues to develop with the famous Balti houses now interspersed with expensive Asian clothing shops and jewellery stores.

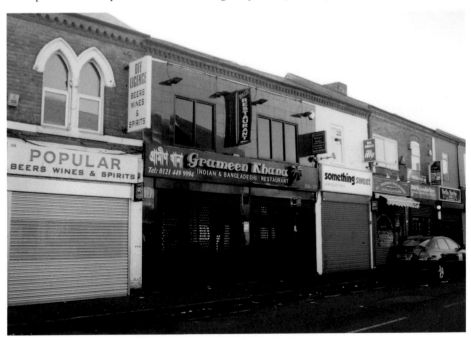

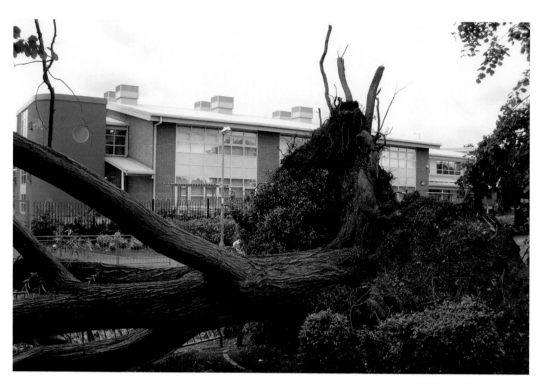

Pickwick Park opposite Clifton School
A huge tree lies uprooted in the foreground though the school itself escaped serious damage. The park is recovering but will be lacking large trees for many years to come.

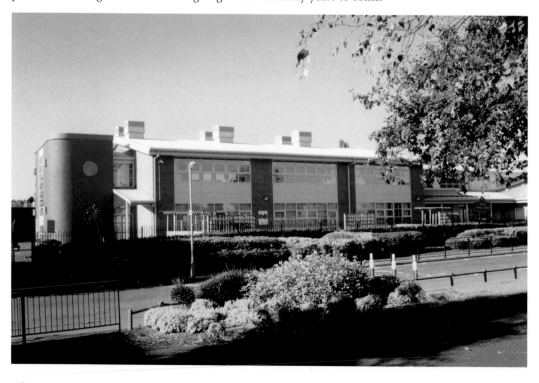

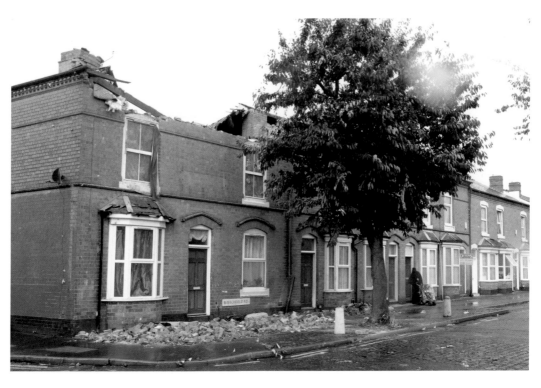

Beechfield Road
Another area of housing where roofs and top floors simply disappeared together with their contents. Beechwood Road has been restored but the memories live on.

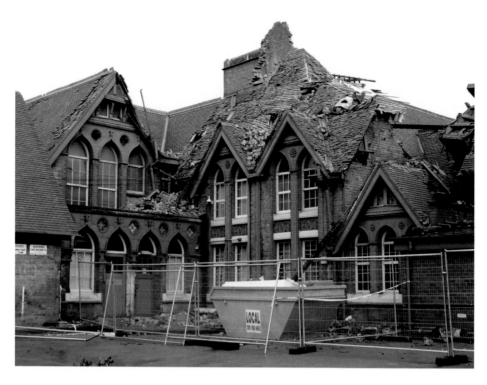

Ladypool School
Built in the nineteenth century, the school is a fine example of Victorian architecture. Sadly in the photograph above, the original tower has gone although the roof has been repaired. Undoubtedly it was an advantage that the tornado happened in the school holidays or there may well have been more casualties.

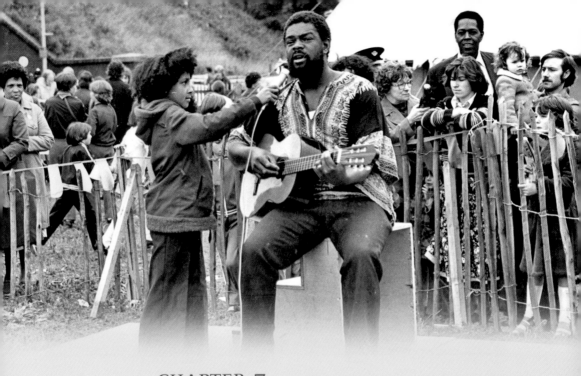

CHAPTER 7

Balsall Heath Carnival

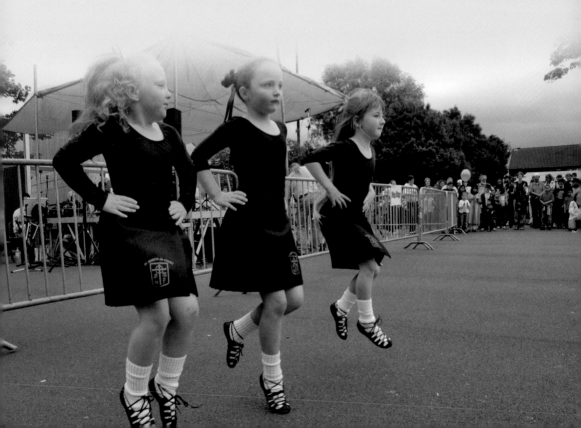

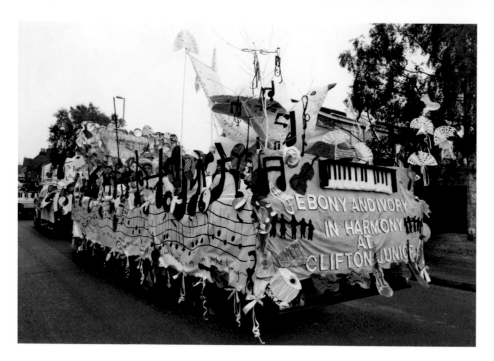

Clifton School

Balsall Heath Carnival started in its present form in 1977 and has been running annually ever since. Floats on lorries were a major feature until 2002 when it became impossible due to City Council restrictions. A long term contributor to the Carnival procession, Clifton School has had to move from floats, as in Ebony & Ivory, to a walking entry. Creative adaptation of a shopping trolley into a Polar Bear, below, made this a highlight of the procession in 2008.

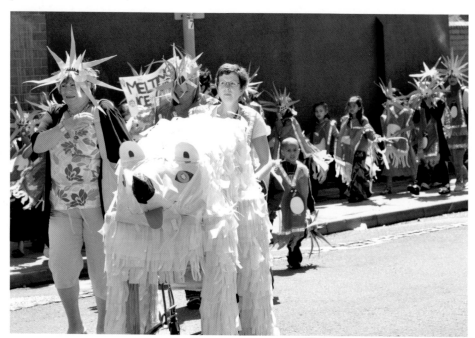

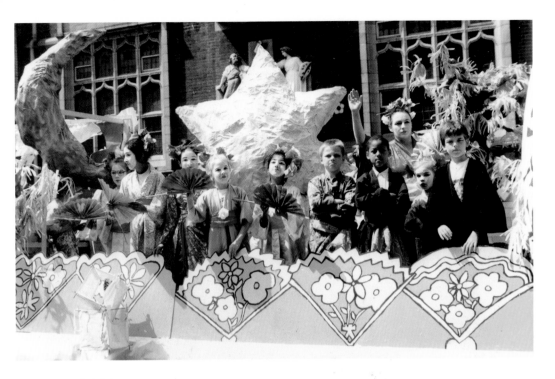

Lots of Children

Huge numbers of children have taken part in the Carnival every year. Above, St Paul's Venture Japanese float in 1993. Below, Clifton School in 2010 who costumed about a hundred children to walk in the procession

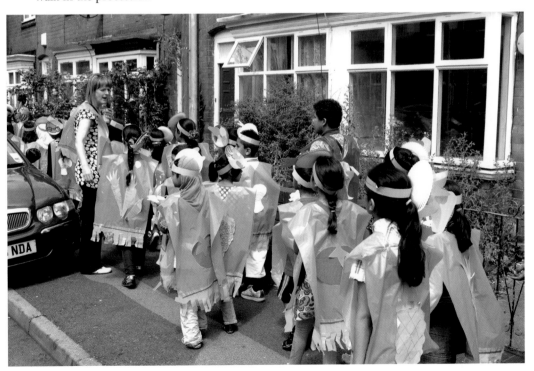

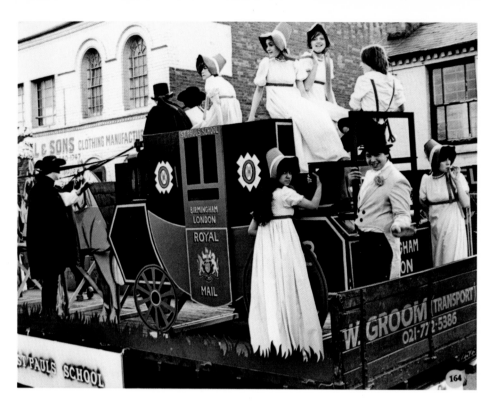

St Paul's School

An example of fine floats on the back of a lorry, the stagecoach built by St Paul's School for the Carnival in 1982, complete with ladies, gentlemen and a highwayman. A later walking entry by the school is shown below with giant willow structures.

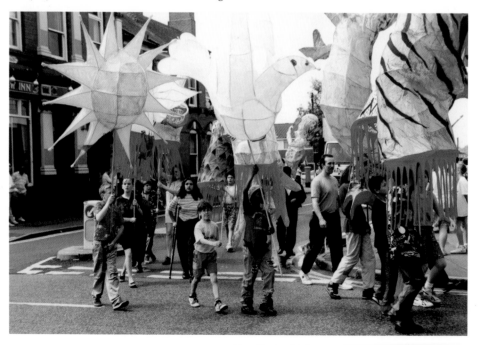

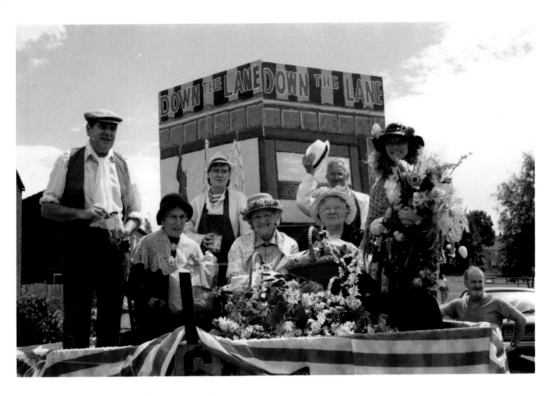

Balsall Heath Local History Society
Always a strong supporter of Carnival, in 1989 the Society presented a float showing shopping 'Down The Lane'. In 2009 it was a walking group of the eighteenth century Lunar Society in Birmingham, including Matthew Boulton.

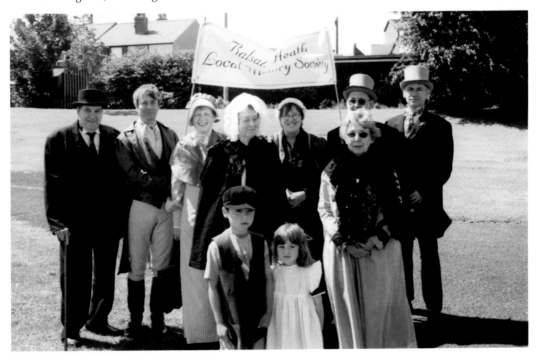

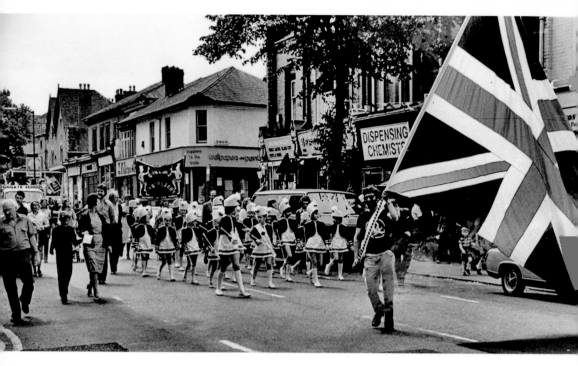

Flagging It Up

For many years the procession was led through the streets of Balsall Heath by Mr Chohan with his enormous Union Jack. The Youth Theatre also led the way later with 'Fantastic Balsall Heath' and an interesting mix of costumed characters.

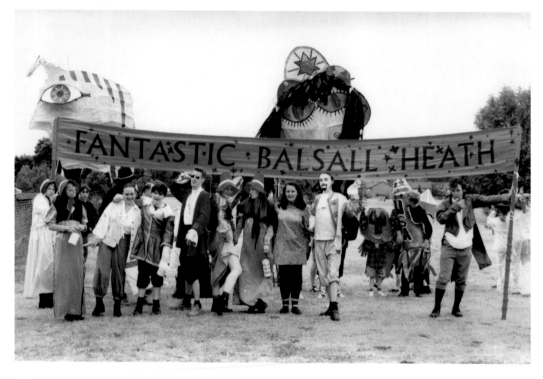

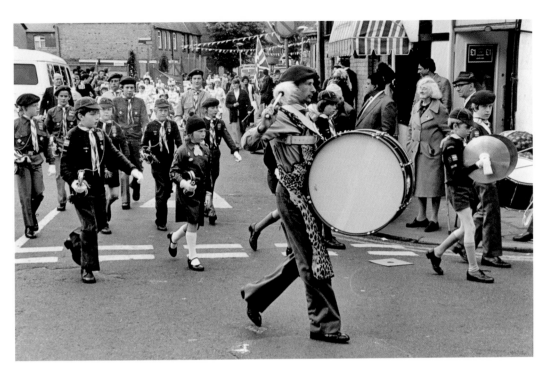

Drums

In 1980 the Scout band provided music and a beat. Samba later took its place in 2004, led by Community Musician, Mark Robertson with a huge contingent of young musicians.

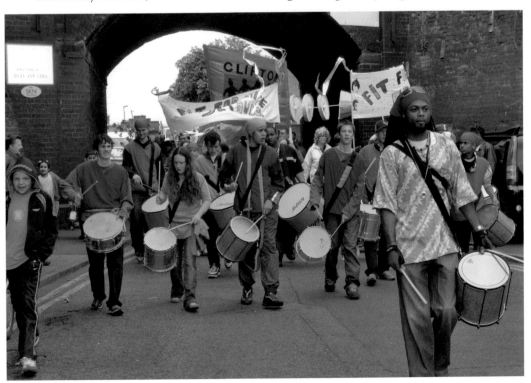

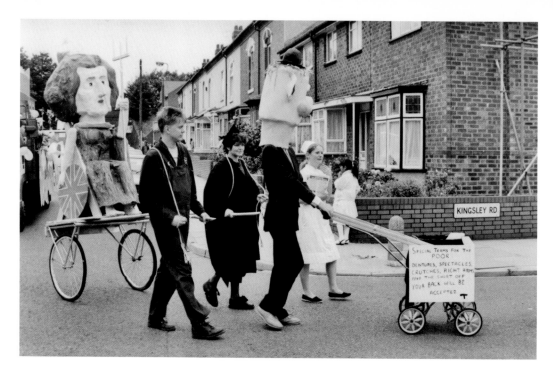

Protest and Fun

The Poll Tax was the cause of this protest entry in the procession in 1989. The sign reads: 'Special terms for the poor. Dentures, spectacles, crutches, right arms and the shirt off your back, will be accepted.' In contrast, in 2006 Sparkhill Children's Centre looked back to the 1970s with a lot of glee.

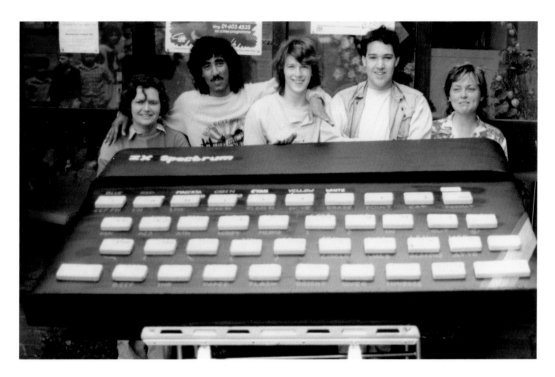

Sign of the Times

In 1984 the Sinclair Spectrum was the newest home computer and St Paul's Computer Club were keen to display their giant sized version, which went in the procession mounted on top of a mini. Below, a group of marshals with Ian Edwards who is currently lead co-ordinator of the Carnival.

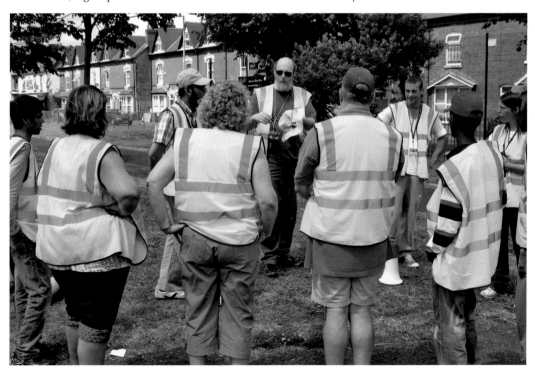

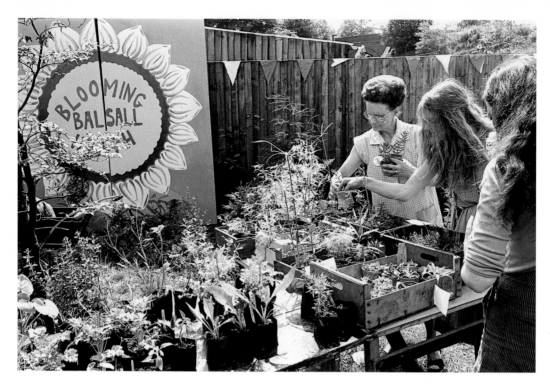

Blooming Balsall Heath

Promoting an interest in gardening and the environment has been a long term neighbourhood priority. The stall above dates from 1981. The Balsall Heath Forum now has its own garden centre in St Paul's Road and at the stall below, illustrating their wares, is Dick Atkinson, Balsall Heath's major Social Entrepreneur.

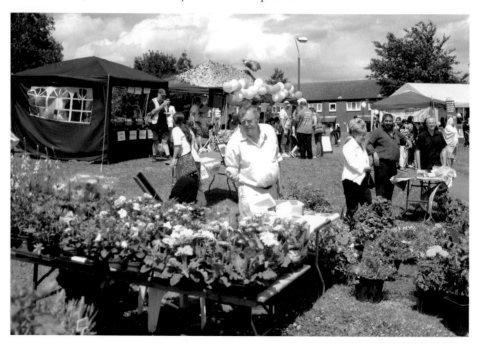

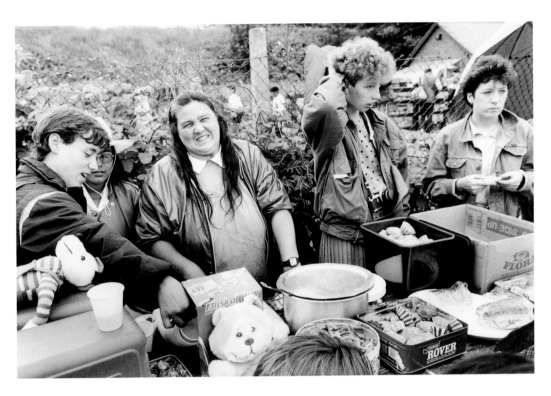

Refreshments

Sandra Uddin in the centre of the photograph above was a stalwart volunteer for many years, here she is seen on a stall selling cakes. Below, Apna Ghar Day Centre for older people, with their refreshment stall. The Carnival Fair is always a feast of culinary delights, with food from many cultural backgrounds.

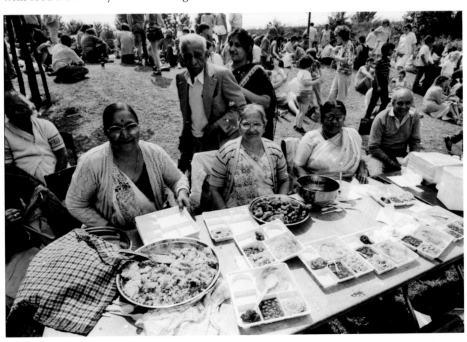

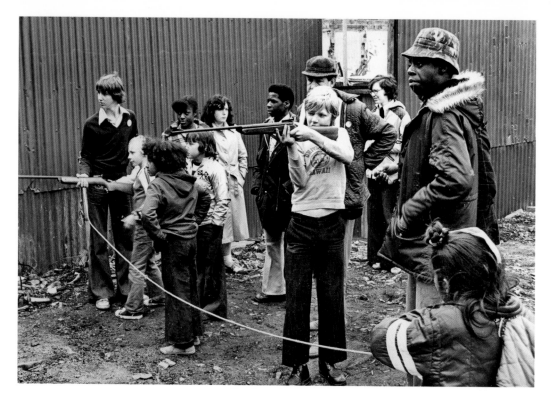

Rifle Range and Inflatable Hammers

It's remarkable to see that the Carnival Fair included a rifle range in 1978, organised by the vicar of St Paul's Church. Revd John Cooper is the man in the centre with his hand on his hip. Inflatable hammers are perhaps less controversial. Clare, who is running this stall, has been coming to the Carnival with it for years.

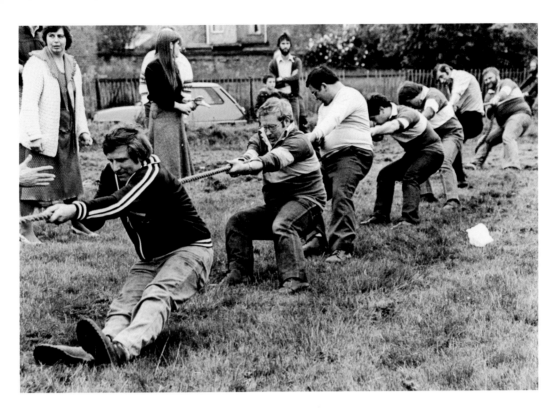

Tug-of-War and Presentations

In the early days of the Carnival a lot of the local pubs entered their own teams for this competition which was hotly contested, sometimes quite frighteningly. Prizes of all kinds are awarded at the carnival and, below, Keith Tatton, May Pearson and Ron Ford are ready to make presentations. All three of these people have been valiant carnival volunteers over the years.

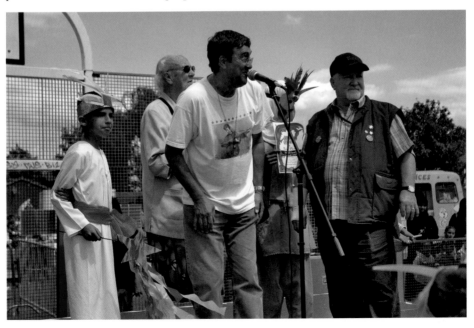

Catapults and the Greasy Log

Most of the activities at the Carnival in the past were home made and the catapult stall is an example of this. Anita Halliday is running it as a fundraiser for St Paul's School in 1979. The greasy log is ever popular, providing a relatively safe challenge.

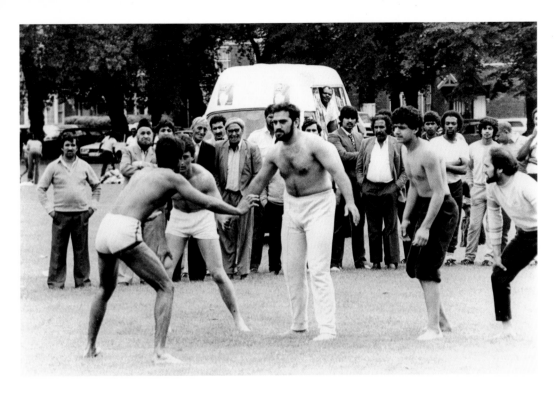

Kabbadi and Singers

Kabbadi was one of the Carnival activities from 1983 to 1989. It is believed that this was one of the first public displays of the sport in Britain. Below, in less active mode, are a group of singers from Edward Road Baptist Church.

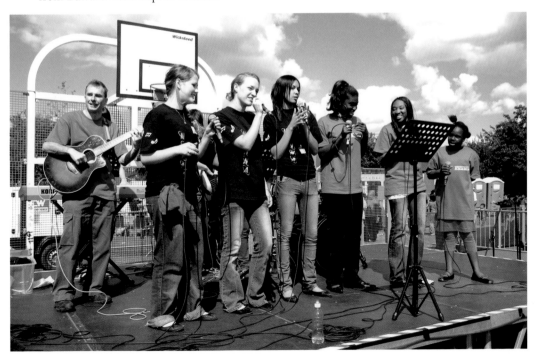

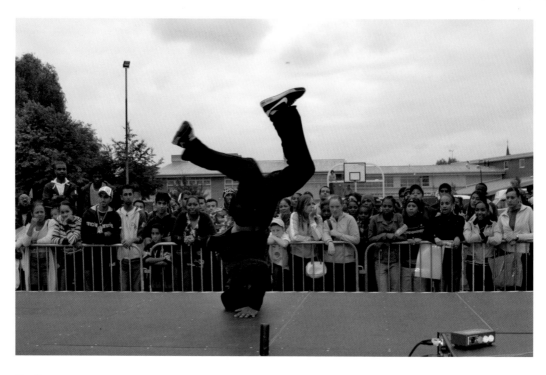

On Stage

One of the glories of the Carnival over the years has been the richly diverse mix of cultures which come together. The staged programme of events in the midst of the Carnival Fair is always a delight. In these photographs: break dancing and Asian music with a sitar.

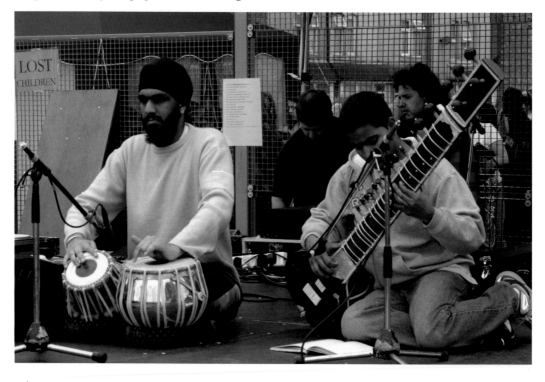